Embroideries

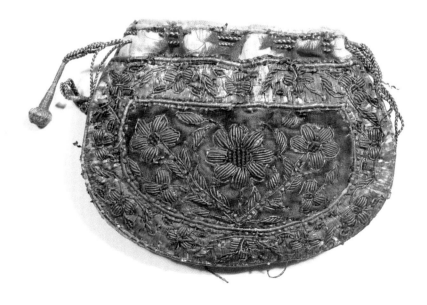

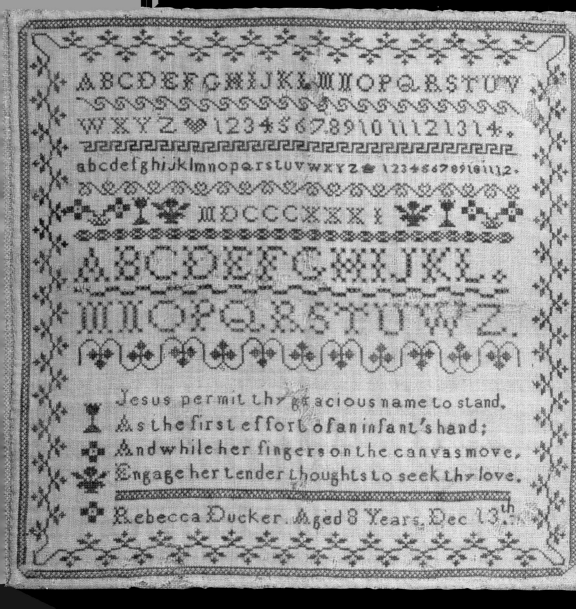

ABCDEFGHIJKLMNOPQRSTUV

WXYZ ♥ 1234567.8910111213I4.

abcdefghijklmnopqrstuvwxyz ❀ 123456789101112

MDCCCXXXI

ABCDEFGHIJKL

MNOPQRSTUWYZ.

Jesus permit thy gracious name to stand,
As the first effort of an infant's hand;
And while her fingers on the canvas move,
Engage her tender thoughts to seek thy love.

Rebecca Ducker. Aged 8 Years. Dec 13.th

Embroideries

by Althea Mackenzie
Special Photography by Richard Blakey

THE NATIONAL TRUST

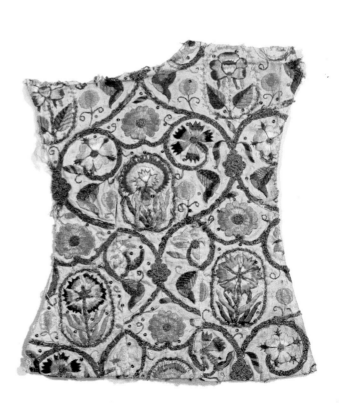

Introduction

The Wade Collection from Snowshill is not only one of the major collections of costume owned by the National Trust, but also represents a private collection of world-class quality.

Its creator, Charles Paget Wade, was born in 1883. His father was part-owner of a family sugar plantation in St Kitts so that he was brought up in comfortable circumstances, although his childhood with his grandmother in Great Yarmouth in Norfolk was spartan. An instinct for collecting was acquired early, along with a strong sense of place and heritage.

However, the world around him was rapidly changing, compounded by the social, political and economic impact of the First World War. For Wade, this meant that much of what he had relied on as a valuable reference was being destroyed by a society that looked away from the past, and forward to a notion of progress based on material wealth and mass production. Traditional modes and mores were seen as unsustainable and undesirable.

Wade's response was to begin collecting objects that had been produced by man's hands rather than by machine. This was very much in tune with the ideals and beliefs of exponents of the Arts & Crafts Movement, such as the architects M.H.Baillie Scott and Sir Edwin Lutyens. In 1919 he bought Snowshill, a derelict but largely unspoilt Cotswold manor, and set about restoring the house and garden drawing on the fundamental principles of Arts & Crafts.

The manor house at Snowshill was the repository for his collections, which covered an astonishing range, from scientific instruments to samurai armour, from cabinets to clocks, from bicycles to kitchen bygones. Wade himself lived in the next door priest's house, to give over maximum space to the objects. In 1948 he decided to hand over his house, gardens and collections to the National Trust. James Lees-Milne, who was responsible for negotiating the transfer of houses to the care of the Trust, found Wade the most eccentric of all the owners he had to deal with – no mean feat in a contest replete with eccentric contenders.

In his diary, Lees-Milne drew a vivid pen portrait of Wade: 'Wearing square-cut, shoulder-length, Roundhead hair and dressed in trunk and hose, this magpie collector would, while showing visitors over the house, suddenly disappear behind a tapestry panel to emerge through a secret door on a different level.'

Wade was, in fact, wearing some examples from his magnificent costume collection. This consists of over 2,200 items, the majority

dating from the 18th and 19th centuries, many unique and most of astounding quality. Geographically the collection incorporates material from diverse cultures; for example, from Africa, Russia and the Middle East. Historically it provides a comprehensive record of changing fashions before the impact of uniformity brought about by the effects of industrial revolution and mass production. The range is vast: 18th- and 19th-century dresses (many unaltered), complete men's suits from the 18th century, beautifully embroidered 18th- and 19th-century men's waistcoats, military uniforms, servants' clothes, ecclesiastical costume, accessories such as hats and shoes. The collection is unusual in that Wade valued the utilitarian and mundane as well as the rare and precious.

Originally Wade kept the costume collection in cupboards, drawers and on display in Occidens, a room so named to evoke associations of the west and the setting sun. The clothes also provided an authentic wardrobe for some of the amateur dramatics that were performed at Snowshill, with friends such as John Betjeman, J.B.Priestley, Lutyens and Virginia Woolf. He intended that a special gallery should be built, but the plan was abandoned with the outbreak of the Second World War. On behalf of the National Trust, the collection was looked after and catalogued by the costume historian Nancy Bradfield, and subsequently by the Trust's own conservators at their studio at Blickling Hall in Norfolk.

Now, while all the other collections remain at Snowshill, the costumes and accessories are housed at Berrington Hall in Herefordshire. Because of the constraints of space, it is primarily a reserve collection available for viewing by appointment. The vulnerability innate in costume restricts display opportunities, although portions of the collection are regularly on display at Snowshill and at Berrington. However, access is vital, and this volume, the third of a series illustrated with specially commissioned photographs, is one way of enabling readers world-wide to enjoy such an important collection.

Wade's costume collection provides a rich and varied selection of items illustrating some of the techniques by which functional objects have been transformed into works of art – here we are concentrating on embroideries. As a consequence of his desire to focus on the art of the craftsman, the majority of examples precede the introduction of machines, particularly the sewing machine which began to make a significant impact in the mid-19th century.

The examples shown in this book date from the Elizabethan period through to the late 19th century. This was a time of considerable flowering in the art and craft of the embroiderer, drawing on the achievements of the medieval *opus anglicanum*. It was also a period when the the influence of growing trade was fully felt on designs, materials and techniques. This rich cultural crossing over is a theme that is followed through in all Charles Paget Wade's collections. Here is a small proportion, arranged very broadly according to the predominant embroidery technique.

I would like to thank Richard Blakey for his patience and skill in taking the photographs, Stuart Smith for his designer's artistic eye, Samantha Bourne for her expertise with the technical information, and Margaret Willes, my publisher, and her assistant Andrew Cummins for coordinating all the disparate elements, of which there have been many.

Lastly, I am grateful to the staff at Berrington Hall and Snowshill Manor for their support.

Althea Mackenzie
Curator of the Wade Costume Collection

Casket

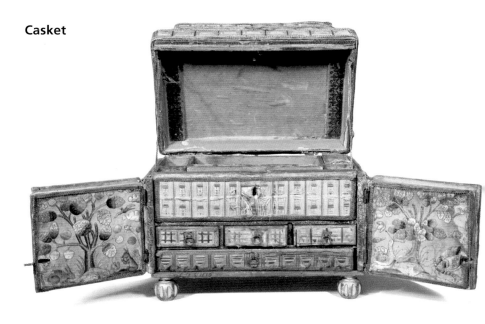

This type of embroidery is known as laid work, a method of covering the surface of a piece of material by arranging lengths of thread in touching rows. These are then secured either by a small stitch at the end of each row, or by couching stitches worked across them. The effect is a smooth silky surface, often within a frame. It can also be described as long and short work, silk shading or needle painting.

The casket, dated 1668, is made of wood and stands on gold-painted wooden feet. It has brass handles on either side and a brass lock on the front. Sometimes known as a toilet cabinet, it could have stood on a lady's dressing table and would have contained a mirror in the lid, and drawers and compartments to hold scent bottles, or sewing tools, or trinkets. This casket has two sections divided into compartments and drawers lined with begonia silk. The top drawer is lined with paper showing sporting scenes. The initial 'MB' appears on the left inside door.

The outside and front of the doors are covered with panels embroidered with untwisted floss silk in various colours laid out in geometric patterns. On the inside of the doors are panels decorated in long and short stitches. On the left is a tree, with a hare and squirrel, and on the right a snail and dragonfly. The edges are bound with silver braid. Embroidery pictures, especially of flora and fauna, were very fashionable and much admired in the 17th century. Kits, with the design hand painted on a silk satin ground, could be bought to be embroidered prior to a cabinet-maker making up the box. The laid work on this casket would have been mounted on paper.

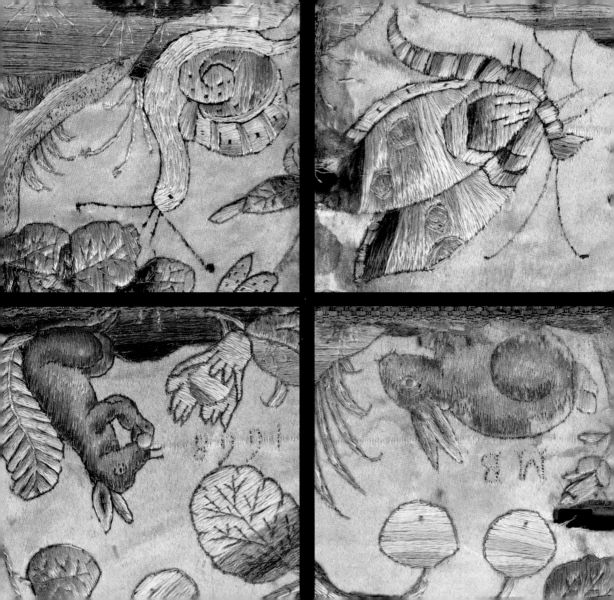

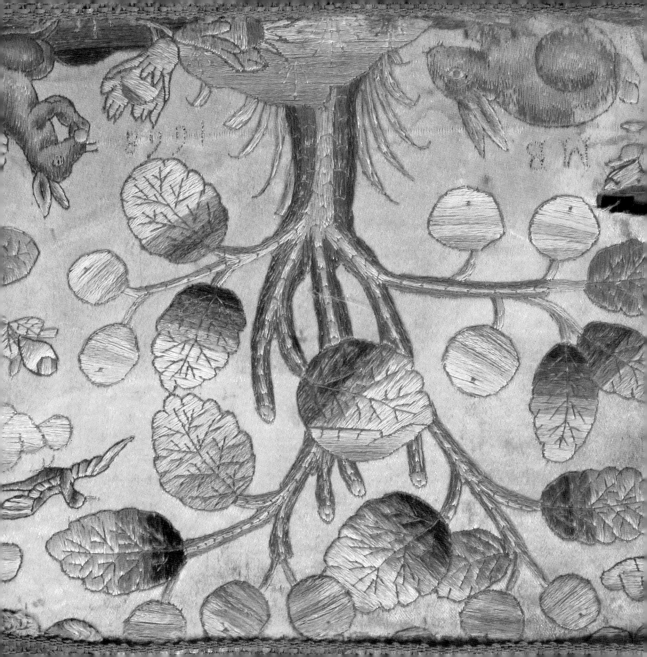

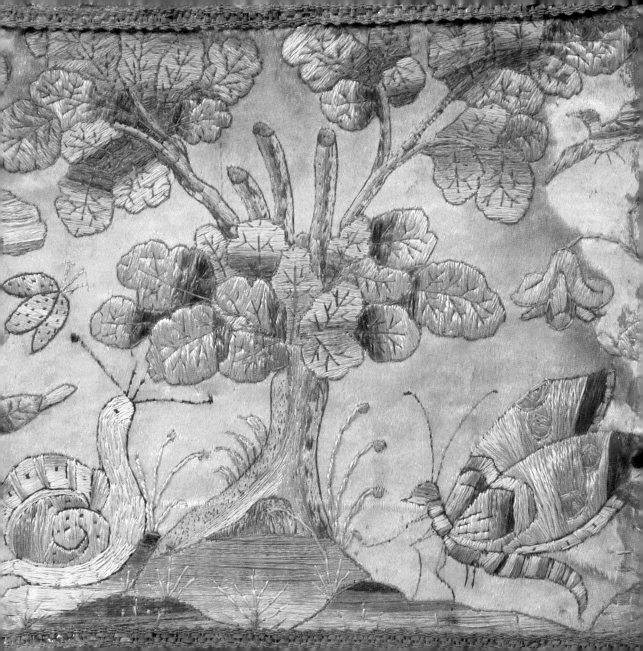

Embroidery Fragment

This delightful embroidery, dating from the late 16th century, is one of the earliest pieces in Wade's collection. It has been pieced and joined together from an earlier garment to form part of a lady's bodice. The design is dominated by thick scrolling stems couched in ogee shapes which combine with beautifully coloured flowers and leaves. The shaded embroidery is carried out in polychrome floss silks with further decoration of metal threads and sequins on a ground of fine linen.

Satin stitch is the main technique shown here. The flower heads have been worked in encroaching satin to produce the exquisitely fine gradations of colour. The scrolls of metal thread have been created by circular and square chain couching.

In the 16th century, flowers embroidered in this way were often described as slips, the term still used by gardeners to refer to their cuttings. The colours, all produced with natural dyes, were favourites at the time – dark and pale blue, green, yellow, orange, brown and red – and have been used to create flowers that were also favourites – marigolds, cornflowers, clove pinks and eglantine roses.

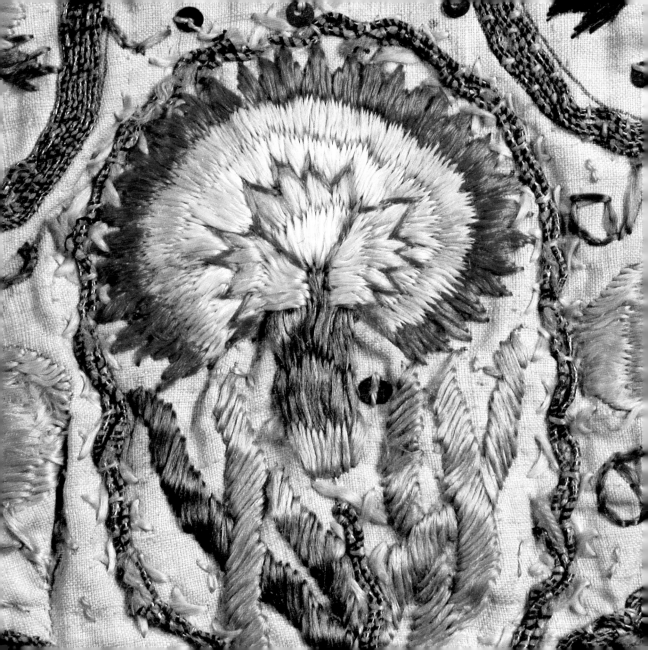

Stomacher

During the 18th century sample patterns of shaded embroidery work were often stitched in small sections or in miniature form and distributed to tailor's and mantua-maker's shops where the customer could select the desired pattern. It was also common for a certain amount of embroidery to be undertaken by the lady and her maids at home. Mrs Delany was well known for her skills with the needle, and embroidered her own court dress with its stomacher of black velvet with silk lace and embroidered pinks and lilies of the valley.

This decorative stomacher dates from the early 18th century, its rich embroidery and trimming providing the ideal opportunity to display the skill of the embroiderer and the wealth of the owner. It would have been worn with an open robe, a gown open at the front, thus requiring a petticoat below and a stomacher above. This delightful example has an embroidered front on a quilted linen rep (a plain weave fabric with raised crosswise ribs). The ground is covered with a backstitched vermicular design. The shaded embroidery is carried out in polychrome silks. Between the front and the coarser linen back are rows of whalebone inserted within parallel rows of backstitching. The edges and front flap are bound with silk tape and criss-crossed with the original decorative round lacing cord.

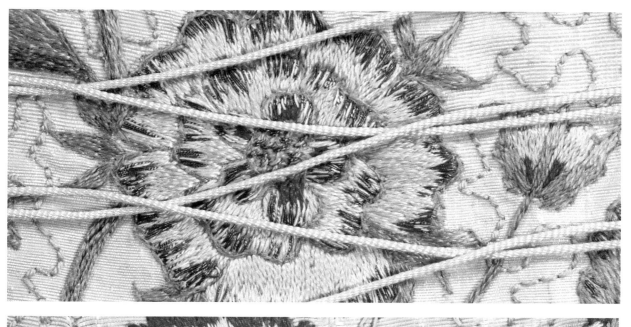
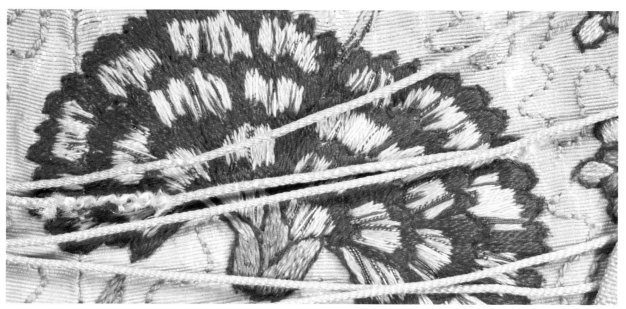

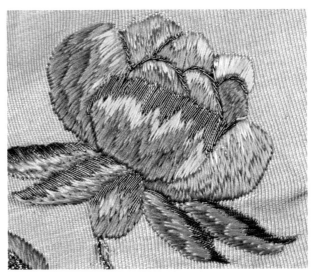

Nightcaps became an essential element of a man's wardrobe after the fashion for wigs and shaven heads was introduced in the mid-17th century. Night in this case means an informal garment worn at home, so these caps might be used for sleeping, but also for relaxing in one's chamber, together with a loose gown, sometimes known as a banyan. The fabric of the cap might match that of the gown.

The absence of a nightcap could cause dire results. In a letter from the Reverend Warner to George Selwyn written in 1779, he records, 'I was going to put on my nightcap.... I could find no cap, so went to bed without it and caught the most terrible cold.'

Often these caps were made from linen or velvet. The 18th century was, however, a time for great re-use of materials, particularly the very expensive embroidered silks. This fine, early 19th-century example of a nightcap is made from sky-blue ribbed silk that was probably formerly a dress fabric. It is charmingly silk shaded with flowers and leaves in floss silks and details of couched passing and rococo metal thread. It is lined with a begonia grosgrain silk. Where the silk embroidery has been lost through wear and tear, the inked out design of the embroidery is evident. The designs would have been pounced with fine powder through a pricked piece of vellum. The remaining pattern of small pin-pricks of powder would then be inked in with India blue ink or, on dark fabrics, white ink made from white lead in a solution of water and gum arabic. Carp gall or brandy was used to thin the solution, which could be applied with a pen or brush.

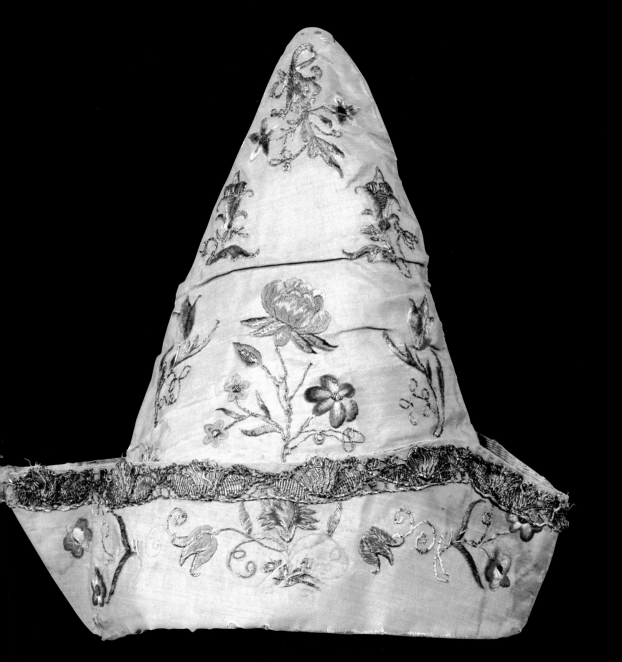

Court Coat

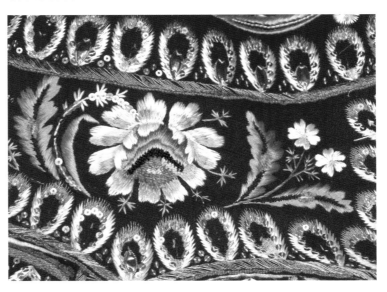

In Britain in the 18th century the style for men was to wear informal frock coats for the country, and court coats for social occasions and for town. Court attendance in the late 18th century was usually at levées held at St James's Palace by George III and Queen Charlotte, and the expectations concerning dress were exacting, providing some of the finest examples of embroidery in Wade's costume collection. Wealth and status were conveyed by increasingly sophisticated and elaborate forms of decoration, particularly on the pocket flaps, cuffs and front openings of the men's coats. It did not go unnoticed that men often outshone women in their dress. Sarah Osborn wrote: 'I believe the gentlemen will wear petticoats very soon for many of their coats are like our mantuas. Lord Essex has a silver tissue coat, and a pink colour lutestring waistcoat, and several had pink colour and pale paduasoy coats, which looks prodigiously effeminate.'

This coat, dating from the 1780s, is made from a rich burgundy napped wool, decorated with sumptuous floral motifs. The naturalistic border design of flowers and grasses is embroidered in threads of multi-coloured untwisted silk, chenille and metal in a variety of flat stitches and French knots. Sequins and spangles, particularly on the border of the silk gauze, feather-like motifs, would have sparkled in the candlelit reception rooms at the palace.

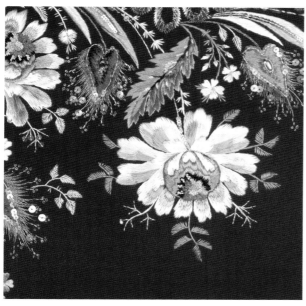
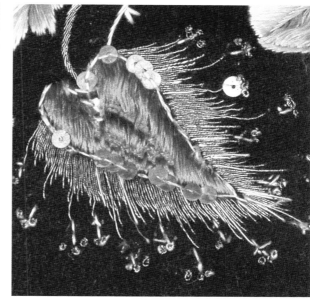
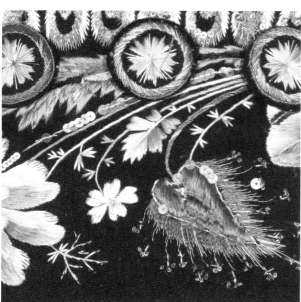

Waistcoat

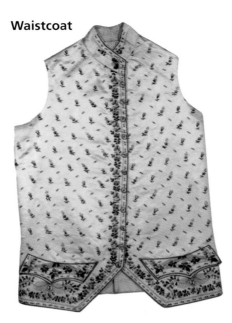

The waistcoat was one of the most popular items of a gentleman's wardrobe during the late 18th century. A man of style might have as many as three hundred in his wardrobe, decorated with embroideries of such diverse subjects as classical mythology, topical politics and exotic flora and fauna. These waistcoats would have been worn with coats which might echo or complement the design. The elegant cut of the coat curving away over the waistcoat would have revealed the underlying embroidery. Many waistcoats were produced in workshops where designs were chosen by the client and then executed by young workers.

It was also quite usual for the lady of the house or her servants to undertake such work. In Richardson's novel, *Pamela*, after the death of her mistress she writes: 'I work all hours with my needle upon his linen and the fine linen of the family, and am besides about flowering him a waistcoat'.

This fine example from the 1780s is made from an ivory silk satin. It is decorated with multicoloured silk embroidery of sprays of flowers running along the leading edges and decorating the pocket flaps and the collar. Satin stitch using fine floss threads make up the flowers and leaves, french knots have been used for the flower centres and speckle 'dots' and a twisted silk thread for the heavy chain stitch borders and buttonholes. The whole of the front surface is covered with an overall design of small flowers.

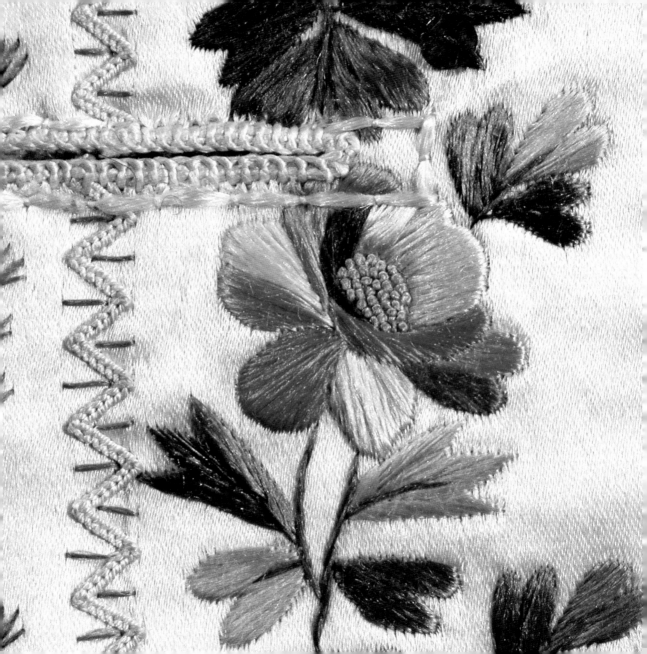

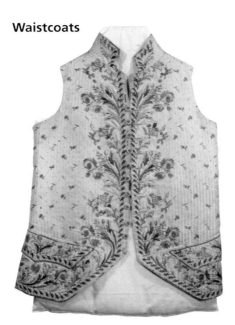
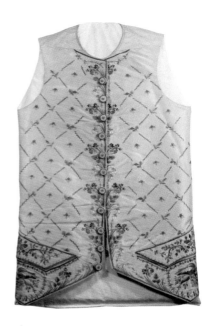

Charles Paget Wade collected over seventy 18th-century waistcoats, representing a whole range of embroidered designs – no two are the same. These examples date from the late 1770s.

The first waistcoat is of ivory fancy ribbed silk, decorated with sprays of flowers and leaves embroidered in multicoloured silks and silver purl (see p. 36 and pp.44-5) and sequins with single flowers embroidered overall.

The second is also made from ivory ribbed silk with running sprays of flowers and leaves embroidered in multicoloured floss silks. The techniques are the same as for the waistcoat on pp. 18-19, with encroaching satin for the large flower motifs and leaves. A pattern of zigzag lines and flowers creates an overall design with a bouquet of flowers at the hem-line.

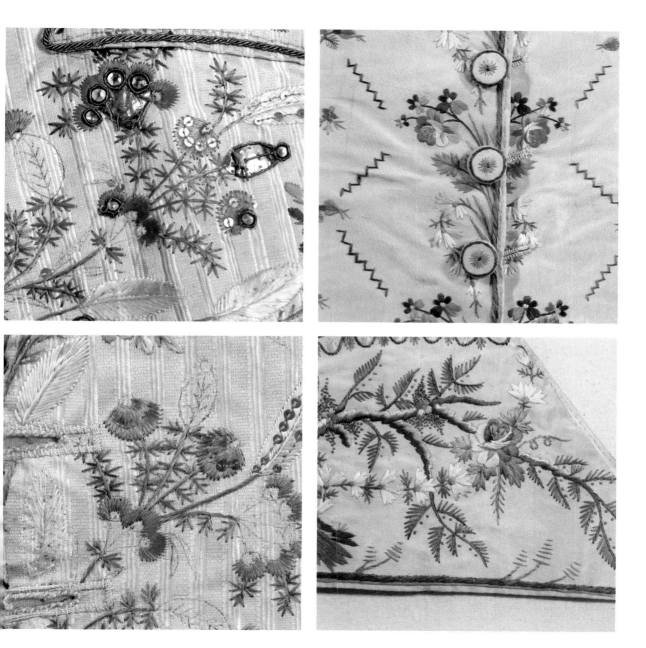

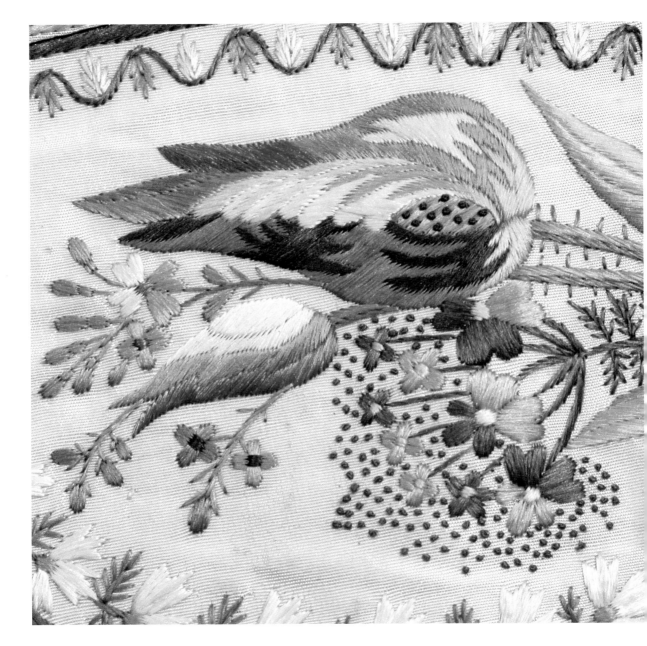

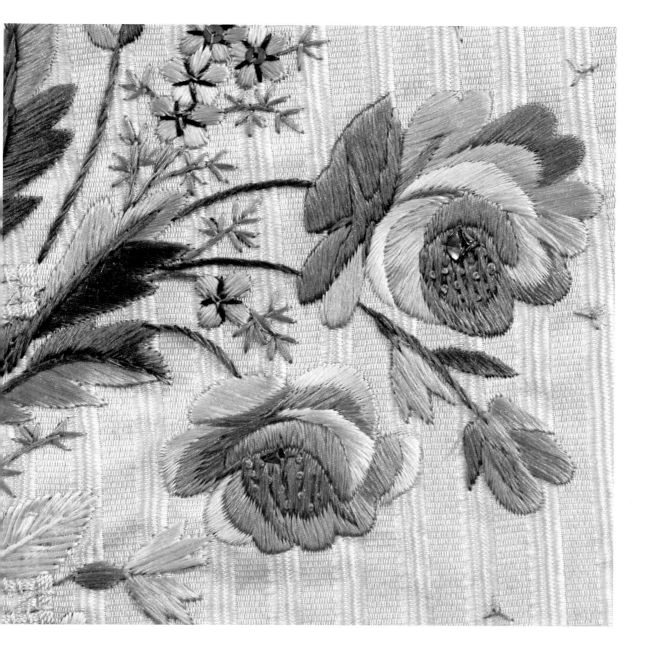

Lady's Waistcoat

The decoration on waistcoats was usually executed before the garment was made up. This made the actual embroidery easier to achieve whilst allowing for the subsequent correct fitting of the garment to the individual client. This 18th-century example of a lady's waistcoat is unusual because it has never been made up. The craftsmanship indicates that it is not of workshop manufacture. Although it displays a fine use of shaded embroidery techniques in heavy twisted silk thread on a cream ribbed silk, and the decorative motifs are skilfully worked in satin stitch with laid work fillings and added spangles, the whole lacks the sophistication of the more professional workshop examples and implies a domestic product. The style and form suggest the waistcoat was probably intended as part of a riding or walking ensemble.

The grosgrain is backed with cinnamon linen and interlined with twill cotton to stabilise the embroidery.

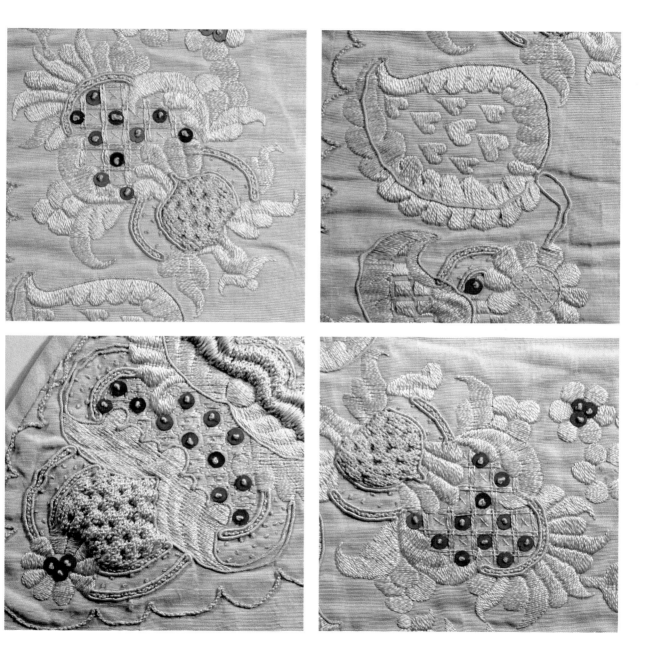

Waistcoat

A cream silk satin waistcoat dating from c. 1800, embroidered all over with flowers and wavy lines in multicoloured floss silks. Sequins are interspersed within the embroidery. The foreparts of the waistcoat are edged with gold and silver braids, black velvet and sequins each with a ring of vellum around. The pockets and collar are also edged with gold and silver braids.

By the first years of the 19th century, the waistcoat was changing shape and this example shows the characteristic square-cut, stand-up collar and welted pockets.

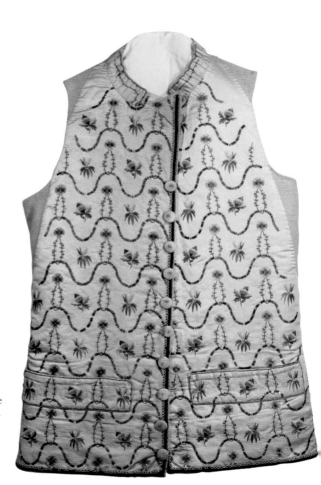

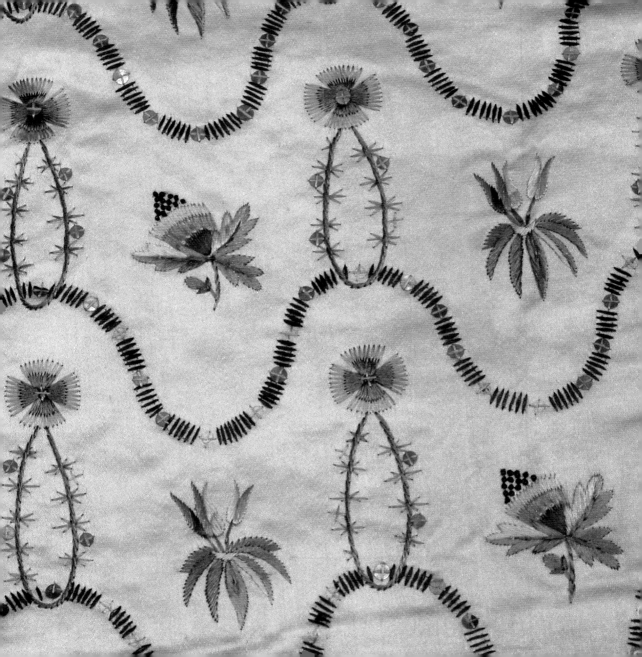

Braces

Braces, sometimes known as 'gallowses' were fashionable from the 1780s when the waistline of men's waistcoats began to rise, often creating a gap between the top of the breeches and the waistcoat's hem. They provided an opportunity for embellishment and became a fashionable addition to the wardrobe. In the early 19th century, when pantaloons and inexpressibles (trousers) took the place of breeches, the effect of braces could be less than flattering, as Dickens described in *Martin Chuzzlewit* in 1844: 'a shabby genteel … his nether garments stretched and strained between his braces and his straps'.

This 18th-century pair of braces is made from cream silk edged with bunting-azure silk ribbon and lined with shell-pink silk. The braces are embroidered the full length with polychrome silks and silver passing, in a chinoiserie design of flowers and insects with the initials 'A' and 'J'. A fascination with the Orient began in the 15th century when porcelain from China was introduced to Western Europe, and this continued right through the centuries as the trade with the Far East expanded and developed.

The braces are fastened by leather straps that encase lines of metal coils to provide a degree of elasticity.

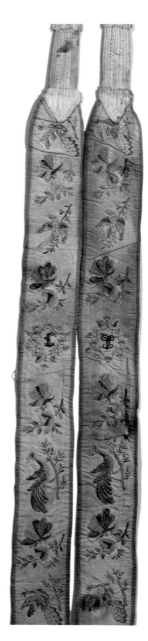

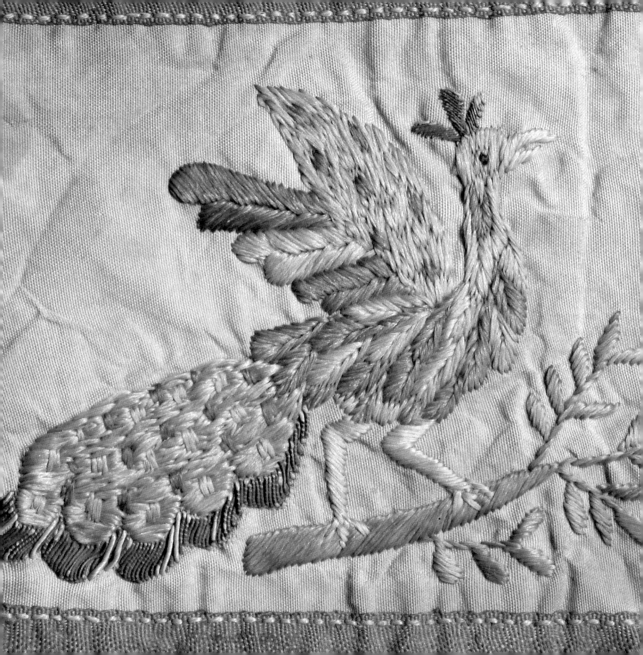

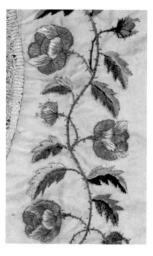

The development of the reticule, ridicule or indispensible during the later years of the 18th century was a practical solution to a problem created by changing fashion. Prior to their adoption as receptacles for female essentials, pockets had been suspended from the waist under the petticoat. These proved impractical when fabrics such as muslin and fine cotton lawn became fashionable; dresses were too light and diaphanous to disguise bulky pockets.

This reticule dating from the 1820s is made from cream watered silk and is embroidered on both sides with floss silk in silk shading and satin stitch, with twining stem stitch for the stems, creating a design of running sprays of pink rosebuds and green leaves.

The lining of the reticule is of cream silk and there is a cream silk fringe and cream silk cord.

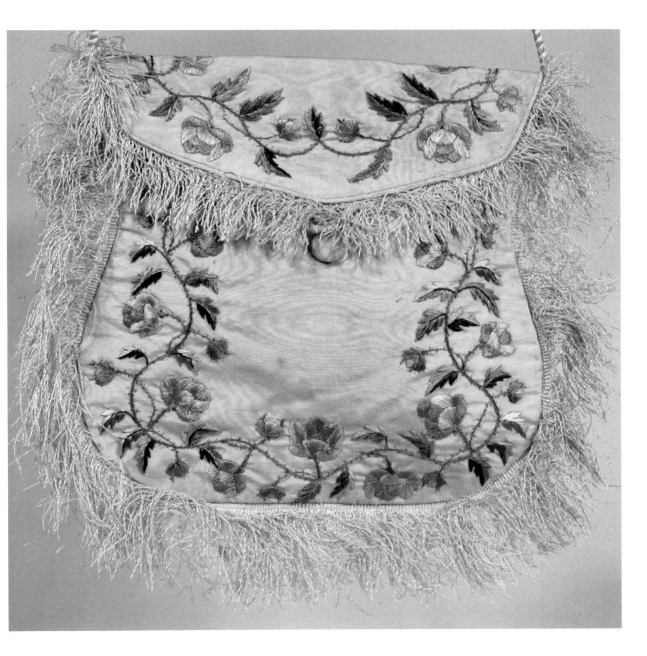

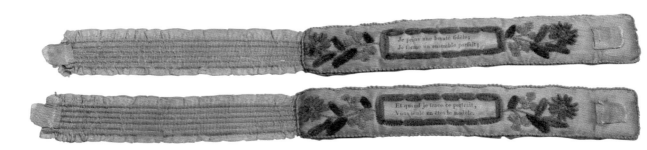

Late 18th-century cream satin silk garters, padded and lined with cream silk tabby embroidered with chenille. Chenille, a thread taking its name from the French word for 'caterpillar', was in use from the 17th century. The thread is formed by weaving a material in which the warp threads are arranged in groups of two to six ends which interlace like gauze, the groups being a definite distance apart to suit the length of the pile. The weft is inserted in the normal way, each shoot representing a potential tuft. The woven piece is cut into warp-wise strips which are then used as weft yarn. The result is an intensity

of colour unsurpassed by any other embroidery medium. It is also known as arrasene work.

Chenille was frequently used in embroidery, the 'hairy' nature of the thread adding to the dimensionality of the design. Garters were often given as gifts and frequently sported slightly risqué verses.

These garters reputedly belonged to Marie Antoinette, and were possibly brought to England by Frances Bulwer, lady-in-waiting to the Queen's close friend, the Princesse de Lamballe. They are embroidered with chenille in a design of small flowers and leaves flanking a rectangular box containing the following inscription :

Je peins une beauté fidèle;
Je forme un ensemble parfait;
Et quand je trace ce portrait,
Vous seule en êtes le modèle.

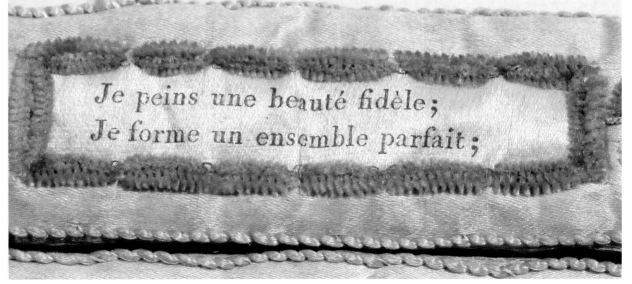

Je peins une beauté fidèle;
Je forme un ensemble parfait;

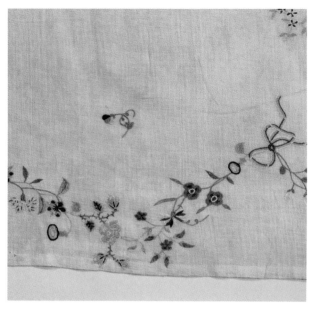

These details from a skirt, probably dating from the 1780s, are a good illustration of tambour work, a method for producing chain stitch on a frame. The technique probably originated in India although some believe it to have come from China. It derives its name from the circular wooden frame, similar to today's embroidery hoop, which is used in conjunction with a hooked metal tool set in a wooden handle. Unlike traditional chain stitching, tambour work does not involve drawing the whole thread through the fabric for each chain. The tool is inserted and the thread is pulled up to form a small loop, the hook is then reinserted and a new loop inserted through the previous one, creating a continuous chain stitch. The chain is both economical to produce and fast, creating several hundred stitches per minute.

By the 19th century, when a great deal of a young lady's time was spent in crafts and arts, working at the tambour frame was the sort of activity considered a suitable pastime, displaying proficiency and artistry to any prospective suitor.

The tabby woven cotton of the skirt has a fine, slightly open weave. It is decorated with tamboured designs of garlands and sprays of flowers in naturalistic colours in polychrome silks.

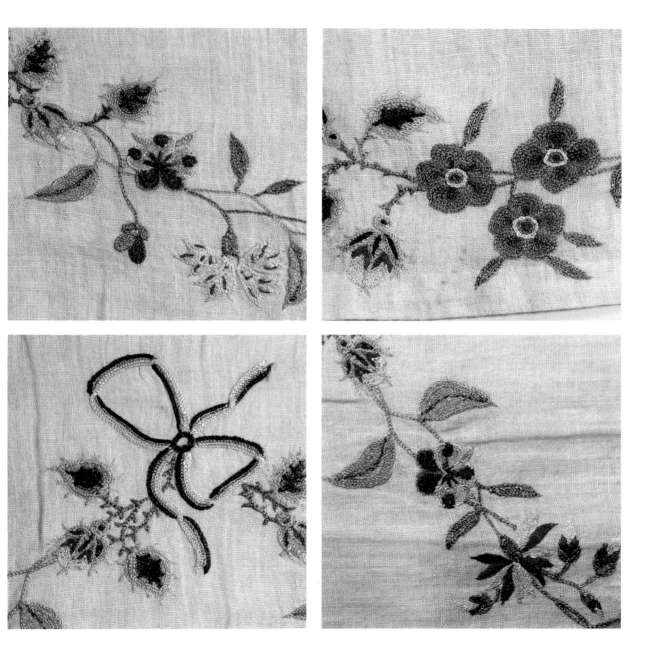

Metal threadwork has been used through the centuries to enhance silk embroidery. There are four main methods of producing metal threadwork. First is passing thread, where metal wire or gold-leaf covered paper is wrapped around a silk core. Contrary to its name, it is usually couched onto the fabric rather than drawn through the weave. The second method involves taking a group of passing threads and twisting them to form a cord, plié. The third takes a thin strip of metal beaten flat, known as plate. This would be laid on the surface, held down with a stitch across, and then folded back and forth over that stitch to give a pleated effect. The fourth method is called purl or bullion. Hollow threads are cut into lengths, and stitched down like beads. The end result looks like satin stitch, with the 'purls' lying close to each other.

The main technique for attaching metal thread is couching, catching the metal theads with small stitches. A certain degree of variation can be achieved through the choice of colour and the displacement of the couching stitches.

This little 16th-century purse is in poor condition but captures something of the richness of its original condition. It is made from linen with a top edge covered in cardinal red satin with a central panel of cypress green silk velvet. The border is embroidered with a couched floral design in purl with a couched passing edge and red glass beads. It is bordered with plate or strip embroidery with green and red beads. The lining is of lichen green silk satin and it fastens with drawstrings of dark blue and cream plaited silk with four small and two larger circular droppers of silk and metal thread.

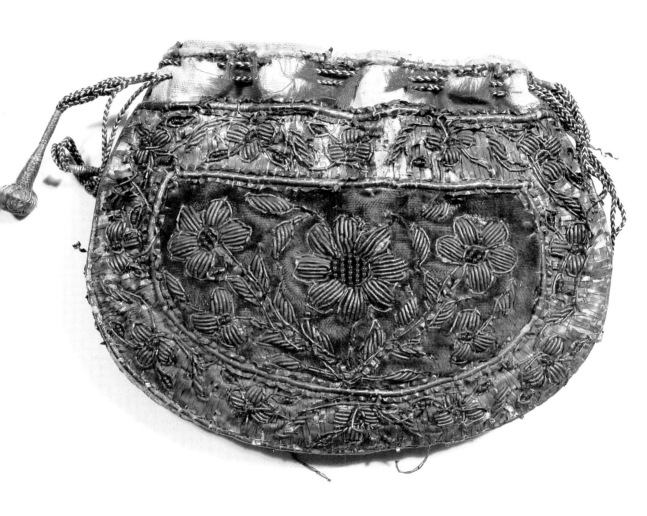

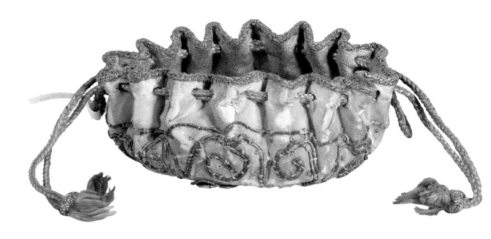

This little gaming purse, dating from the late 16th or early 17th century, is typical of the style popular throughout Europe. These flat-bottomed drawstring pouches were used for carrying gambling tokens or money. They were often richly embroidered and decorated.

This example is probably Spanish or Portuguese, and is made from vellum or card covered with cream silk and embroidered with a floral design worked in coloured silk floss and couched silver threads. The lining is of dawn-pink glazed linen. Green plaited cord and silver thread edges the purse which also has drawstrings of sea-green plaited silk cord. The drawstring ends with simple tassels headed with silver thread.

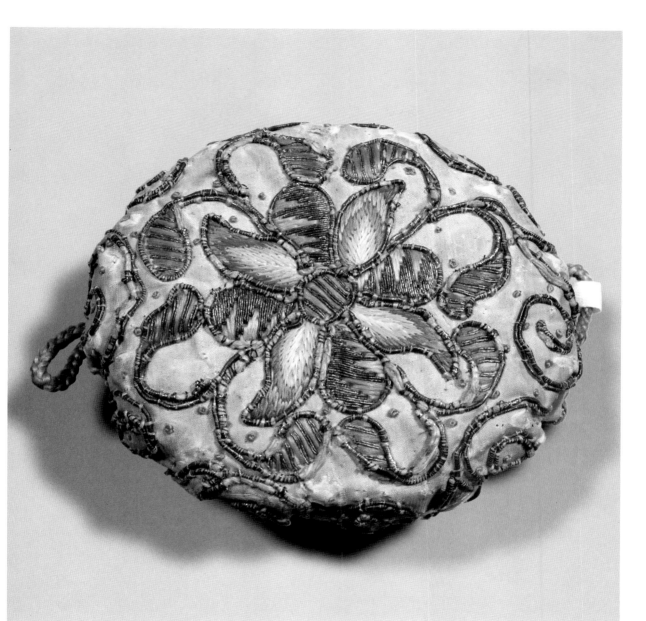

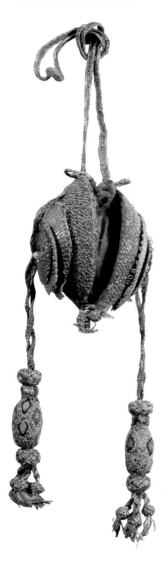

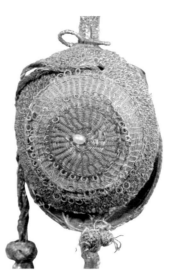

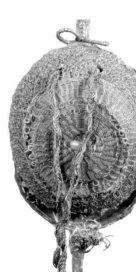

Purses came into increasing use during the 18th and 19th centuries, and were often made at home and given as gifts. There were several typical forms, the most popular and long-lasting being the miser purse – a long-netted tube with tasselled ends, a central split and two sliding rings for securing the contents. Another popular form was the thimble or guinea purse, later called the sovereign purse after the introduction of that denomination in 1816. Designs for purses were often suggested in ladies' magazines. Catherine Hutton recalled netting upwards of one hundred wallet purses amongst her embroidery creations.

This little mid-18th-century purse is made from three concentric discs on each side of a shell, the lower disc is silver, the middle yellow and the top begonia. Each disc is made of coiled silver thread held together with coloured silk, and in the centre of each half is a pearl. The purse is further decorated with a begonia-pink and silver-plaited cord with two tassels of interwoven silk and metal threads.

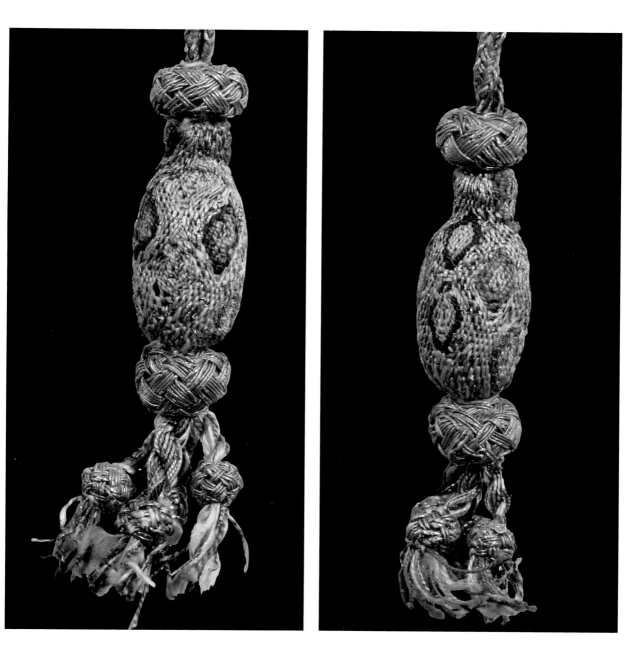

Wade's collection contains embroideries from different parts of the world. He set out to collect these to illustrate the rich cultural diversity in design and craftsmanship, while also highlighting similarities and common themes that repeat and recur. As he explained: 'At first I intended to keep to English things, but found there was little with the attraction of colour, save heraldry. Strange after the splendid use of colour in the Middle Ages. I therefore turned to the golds, vermilions and blues of Spain and Italy. I then looked to Persia, and eventually to the Far East where the three essentials of design, colour and craftsmanship are attained to the fullest.'

The origin of this little late 19th-century bag is not known, but its style is Middle Eastern. It is made from natural cotton, crudely block printed or painted with vegetable dyes in curvilinear shapes, simple flowers and Arabic characters. The printed/painted areas are outlined in metal thread chain stitch. There is a cord of metal strings. It is edged and has a central medallion of crochet worked in matching metal thread.

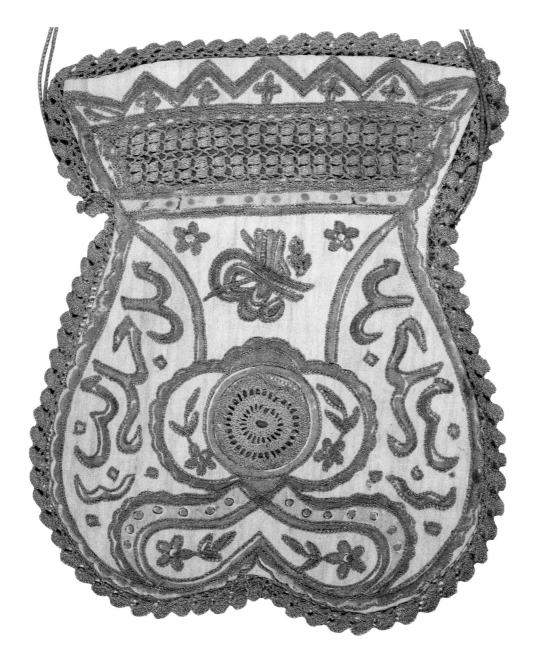

Metal threadwork and metal lace were often used during the first half of the 18th century to decorate and adorn men's costume. The effect was twofold, the silver enhanced the garment in candlelight, and at the same time clearly displayed wealth.

This kind of embroidery provided a wonderful complement to fine shaded silk embroidery. It was most applicable to the exquisite decoration on a man's waistcoat. The original term 'embroiderer' refers to the skill of applying gold, silver or coloured thread to decorate an already woven fabric.

This detail of a pocket from a waistcoat dating from the 1750s illustrates such skill and workmanship. The silver purl embroidery has been applied to the duck-egg blue silk satin in long, floating lines to create a flat finish that looks as if it has been woven into the silk.

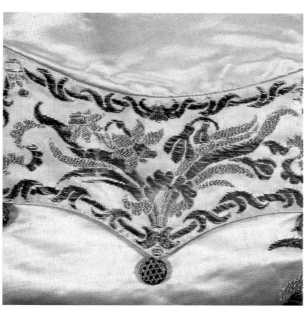 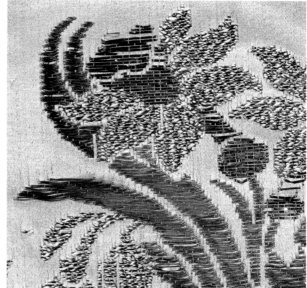

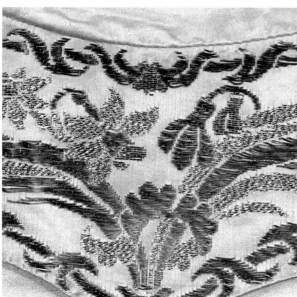 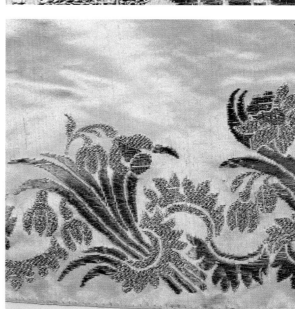

This gentleman's court coat dating from the late 18th century is made from beetroot silk velvet with scattered sequins of silver, possibly silver over copper. Sequins, also known as paillettes, were traditionally made by coiling a circular silver wire tightly around a long core of wood or metal. The coil was cut along its length with a fine saw, releasing a series of small wire rings that were then hammered to form perfect circles with a central hole. Many of the designs incorporating sequins often take advantage of the variable sizes available to give even more effect to the design. It is a method that is still widely used in parts of Asia.

This coat may have been made in India, where nabobs like Lord Clive wore extravagant and sumptuously decorated dress to exhibit their wealth. This roused the wrath of Horace Walpole, who complained of a 'sink of Indian wealth filled by Nabobs and emptied by Macaronis [young aristocrats of St James's who adopted exaggerated manners and modes of dress]'.

The rich velvet is exquisitely decorated with silver thread and sequins in a design of palm trees and other foliage. The cuffs are of cream silk ribbed with silver and the edges of the coat, the pocket flaps and the cuffs are similarly richly embroidered with foliage and palm trees in silver threads and sequins. The large flat buttons are covered with silver foil, silver threads and paste jewels.

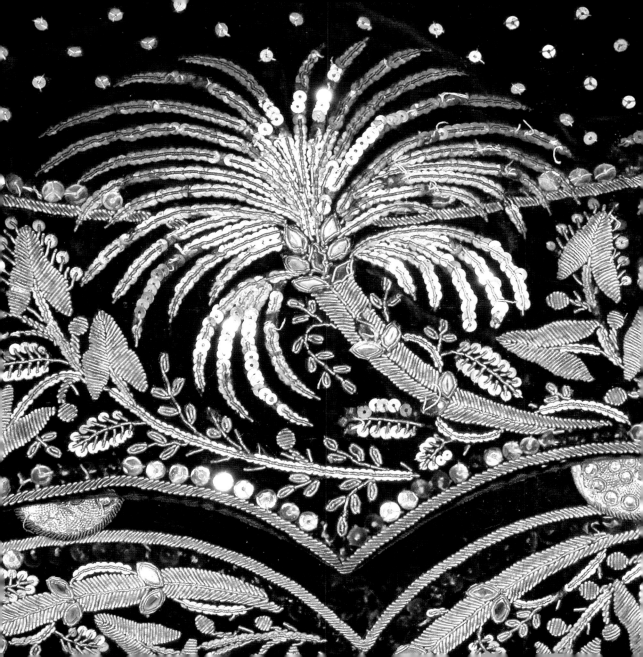

It was the Church that originally provided the stimulus for fine embroidery, flowering with the *opus anglicanum* of the 12th and 13th centuries. In the 18th century there was another revival when altar frontals and ecclesiastical costume again provided an opportunity for the display of much fine embroidery.

All the expertise of shaded silk and metal threadwork can be seen in the delicate floral designs of this chasuble front of cream taffeta. The silkwork is made with floss and twist silks, the metal work with fine thread couched in a pattern.

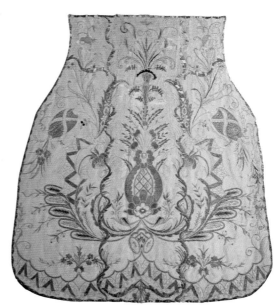

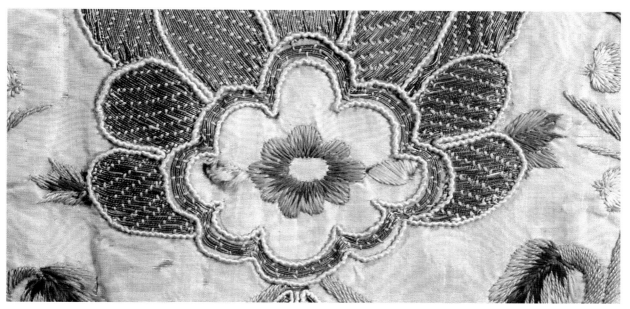

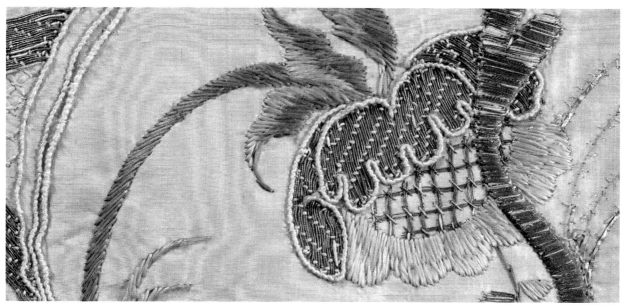

Trumpet Banner

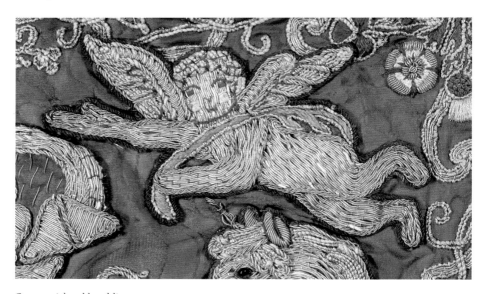

Ceremonial and heraldic embroidery provided a medium for professional design and craftsmanship as seen here. It would have certainly been produced in a professional workshop. The metal thread-work is formed over a padding which was generally either wool or vellum, the ultimate effect being to produce a raised and three-dimensional design.

This Victorian example of a trumpet banner has a red silk background with a blue silk backing and the Royal Coat of Arms with 'V R' and a gold fringe. Every conceivable metal thread is used: passing, purl, rococo (kinked passing), cord, with some silk threads.

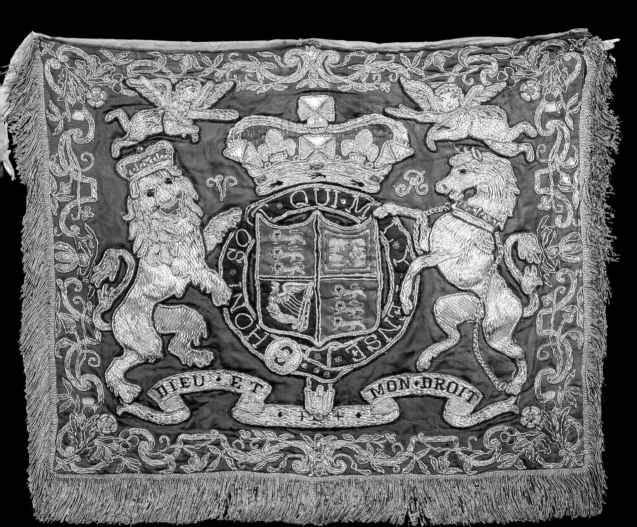

Saddle Cloth

The 18th century saw a great increase in outdoor pursuits for both men and women. Riding was one such activity and offered the opportunity for the development of specific riding costume and accessories. A lady's riding habit would have been made by a tailor, and owed much to male and military costume. The fashion aimed to draw attention to the rider as well as provide comfort. In 1770, during a visit to Nuremberg, Lady Mary Coke remarked 'the novelty of my dress drew an abundance of people about me; to say the truth, I was mobbed.'

The saddle cloth equally provided an opportunity for display. This saddle cloth would have been owned by a lady of substance. The sumptuously quilted crimson velvet is padded with lamb's wool and interlined with coarse hessian. There is a cream and crimson braid decorating the edges, the top of the saddle and the pommels. At each corner is a raised design, guipure, of stylised leaves, stems and flowers worked in silver wire over vellum. The art of cutting the vellum for guipure embroidery was highly skilled and demanded both technical and artistic confidence. The overall effect was to produce the design in relief.

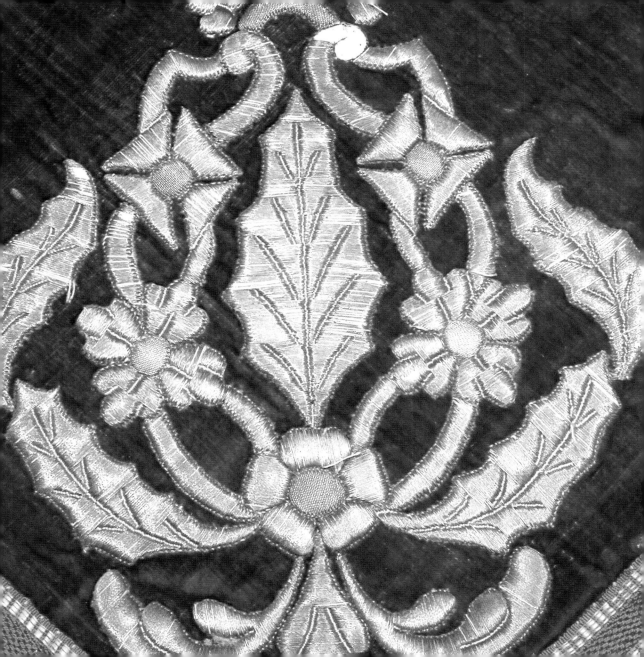

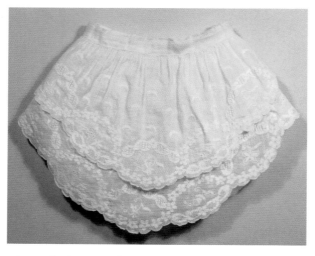

Whitework refers to any form of embroidery where white threads are used on a white ground and includes surface stitching, cut work, pulled work and drawn threadwork. The most complex of this type is Dresden work, also known as pointe de Dinante, point de Saxe or toile-de-mousseline. Originating in the 18th century, the drawn embroidery on a cambric or muslin ground could be used as a substitute for fine lace. Often it was of such value as to be bequeathed in wills. In 1764 Lady Heathcote's husband wanted his wife's sister to have: '3 little Parcels of Dresden Work and blond [lace] not made up.... He said

he was particularly desired to give them to me, he had always kept them separate and accordingly sent them without my knowledge ... they are of some value.'

Patterns for gowns, aprons, caps and handkerchiefs were published in *The Lady's Magazine* from 1770 on. The embroidery motifs were usually stylised floral or plant forms, with the areas between the motifs characteristically worked using a pulled thread technique. This involved the displacement and rearrangement of the ground fabric's threads that were then stitched to maintain them in their altered configuration.

These fine mid-18th century

cuffs would have pinned to the dress of choice. They are made from white cotton lawn decorated with Dresden work with crescent moons, sprays of single flowers and trails of daisies. The scalloped edges are buttonholed.

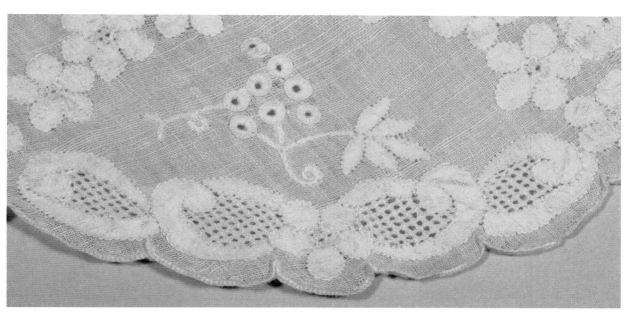

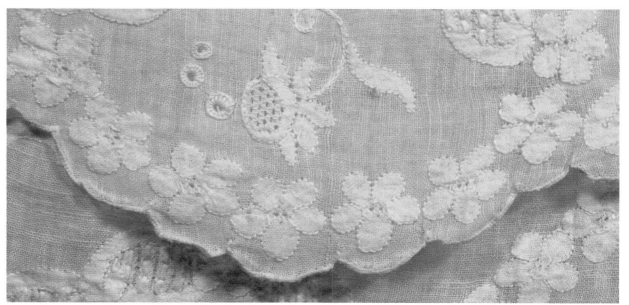

In the 19th century Dresden work was often designed to be mounted onto net for collars and blouses. The detail of a collar shown above is of fine cotton embroidered with five rococo motifs with heavy satin stitch sprays and punch stitch fillings. The borders have lighter sprays of feather stitch and round flowers with needle-lace fillings.

Such collars and other white-work additions were intended to be removed for washing.

The detail of a jacket, right, is made of Coggeshall lace. This type of lace was made at Coggeshall in Essex from around the year 1820. Machine-made bobbin net was embroidered or tamboured with sprigs of flowers and trailing foliage. It is also known as Limerick lace after Charles Walker took a group of lacemakers to Limerick in 1829 and founded a manufactory there based on a combination of philanthropy and commercialism.

The white muslin jacket, dating from the late 19th century has a lace design executed in chain stitch. It reflects the growing use of lace as part of the female costume, much of which was produced by the ladies of the house.

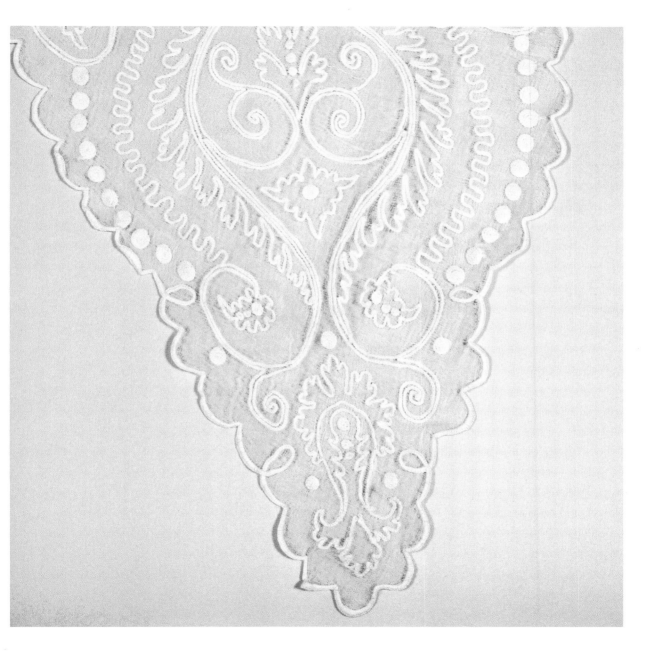

Child's Cap

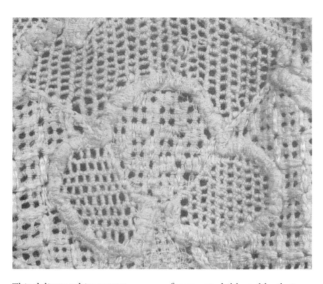

This delicate white cotton children's cap, dating from the mid-19th century, is constructed from three pieces and beautifully hand embroidered *en disposition*. The decoration consists of rows of leaves and berries in satin and eyelet stitches. The round crown is embroidered with feather shapes in stem and satin stitch around an open-work centre of needle-run net. It is lined with a fine cream woollen fabric, possibly of a later date. There is a narrow Vandyked frill around the edge, and it has two cord drawstrings on the brim and one at the neck.

During the 18th and early 19th centuries it was normal for young children, like their mothers, to wear day caps. The *Lady's Monthly Magazine* of 1799 recommends that 'two caps should be put on the head until the child has most of its teeth'.

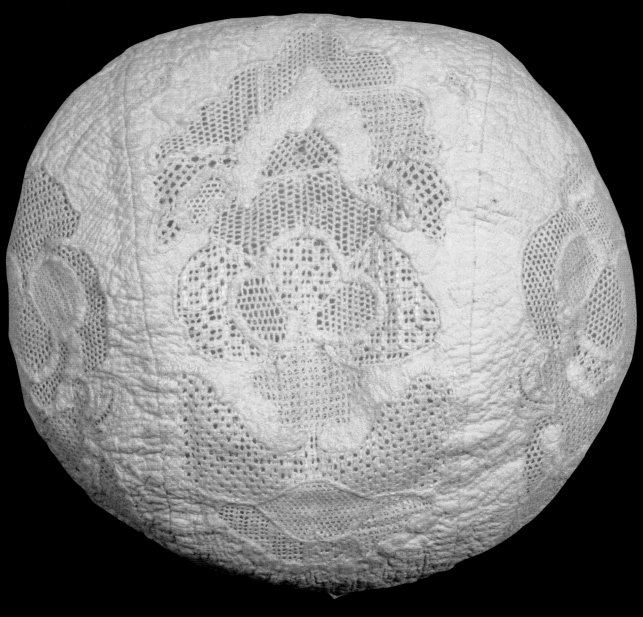

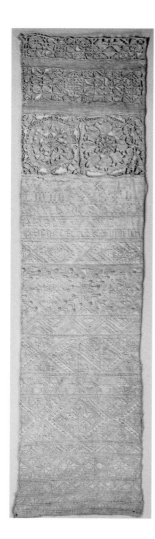

Reticella, also called Italian cut work, Greek lace or Gothic point, is a lace made by embroidery methods. Warp or weft threads are drawn out and then grouped together and sewn over to produce the design. What is referred to in Italian as *punto tirato* (single open work) has one layer of either the warp or the weft removed, *punto tagliato* (cut open work) has both warp and weft drawn out.

Samplers, samp-cloths or sam cloths as they were sometimes known, were the equivalent of embroidery notebooks, representing a variety of stitches, patterns and designs for the embroiderer to remember. Palsgrave defined a sampler in his dictionary of 1530 as 'an exemplar for a woman to work by'. They were used by amateur adult needlewomen and could be rolled up and kept in a work basket when not in use. A poem by William Barley in his *Booke of Curious and Strange Inventions called the first part of Needlework* published in 1596 advised:

Keepe cleane your samplers, sleepe not as you sit
For sluggishness doth spoil the rarest wit.

The 17th century is regarded as the golden age of sampler making right across Europe. These pieces of embroidery represented many hours of labour and were therefore of significant value, often left to daughters in wills.

This is a typical example of the 17th-century band sampler style, measuring 61 x 16cms (24 x 6 $\frac{1}{8}$ins). It is worked on a fine linen ground in natural linen thread. The top three bands are embroidered in reticella, the next 13 decorative bands are divided by rows of hem stitching and include an alphabet in eyelet, an alphabet in geometrical satin stitch and 11 bands of pattern, mostly in geometrical satin stitch with some eyelet, double running and loose buttonhole stitching. There is no legend or date.

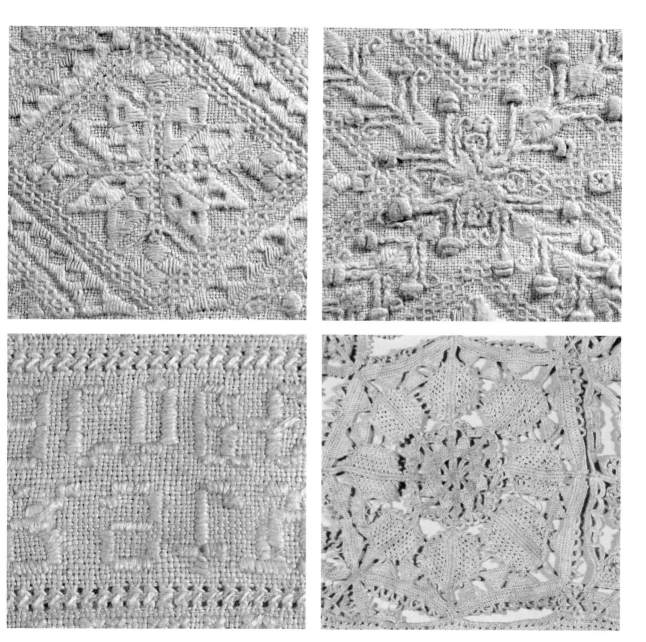

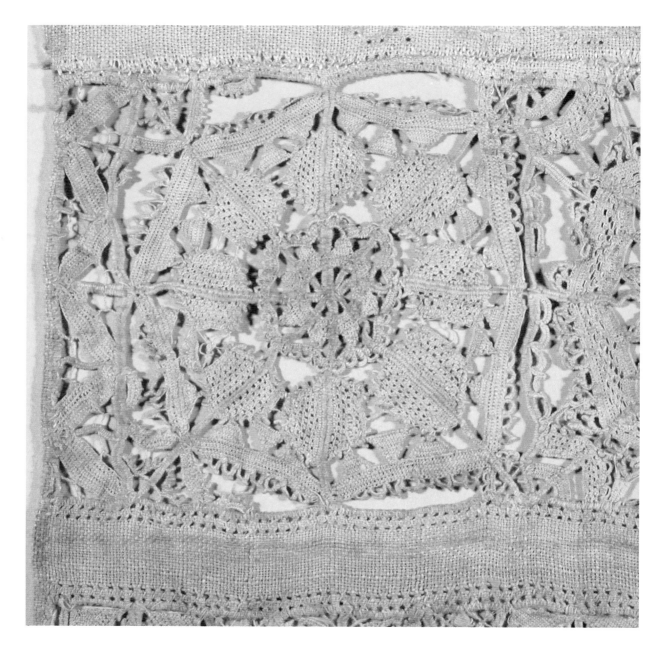

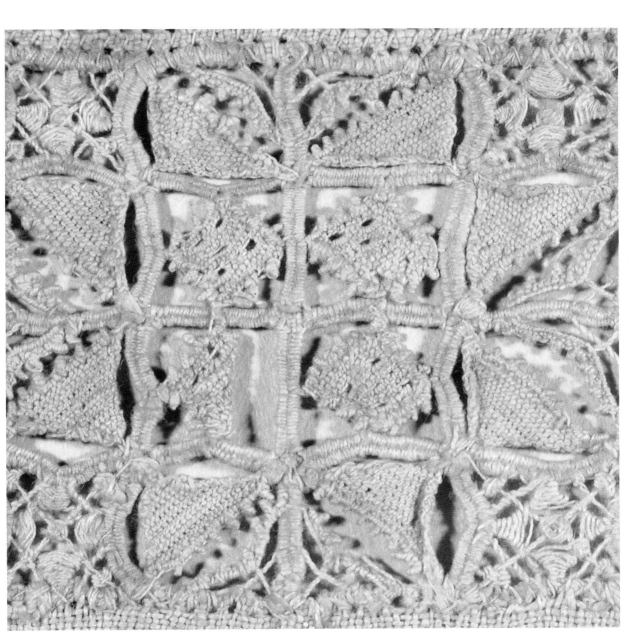

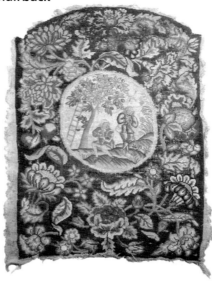

Needlepoint or canvaswork is a technique worked on an evenly woven, stiffened cotton or linen fabric. Sometimes it is described, rather confusingly, as tapestry. Many varieties of stitch are used – cross or tent for the intricate designs, and more elaborate stitches such as gobelin or straight for the backgrounds.

This type of work, with its hard-wearing qualities, flourished in the 17th and 18th centuries, particularly for upholstered furniture. The subject matter of such embroideries was often pictorial and full of symbolism.

Needlepoint and canvaswork were popular pastimes amongst the ladies of the household. After her marriage, Mrs Delany made covers for her drawing-room chairs, one set for winter in worsted chenille, each decorated with a different group of flowers, and a second set for summer in blue linen decorated with husks and leaves in applied white linen.

The ground for this early 18th-century chairback is a coarse, unbleached jute canvas. It is worked in tent stitch in thick untwisted silks and wool – the silks have been used as highlights to lift the palette of the wools, which could be drab. The central medallion illustrates two men harvesting apples. The large bouquet of flowers is worked in gros point (tent or cross stitch embroidery worked across double threads of the canvas).

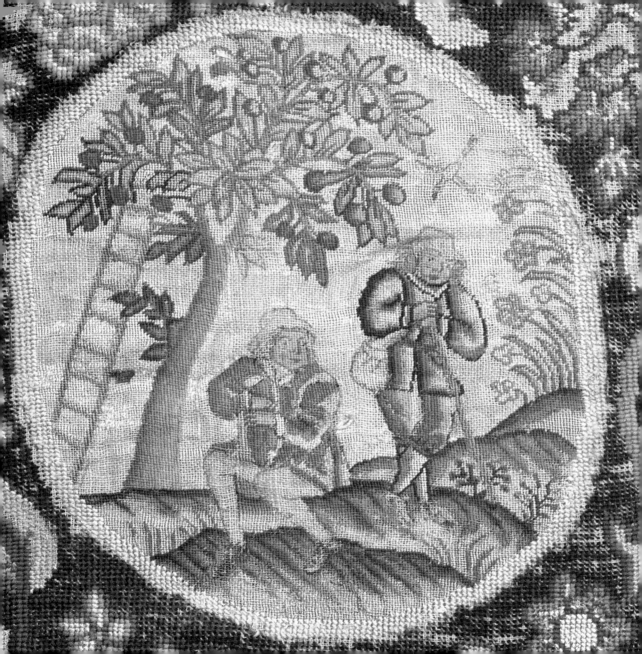

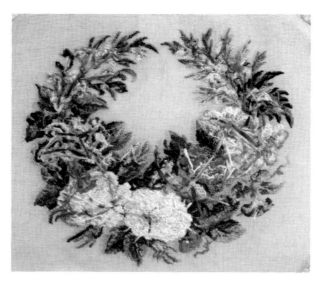

Petit point (tent stitch working across single threads of the canvas) was a popular pastime for young ladies during the 19th century. Jane Austen makes many references to her characters' involvement in needlework. In *Mansfield Park* Lady Bertram is described as 'a woman who spent her days in sitting nicely dressed on a sofa, doing some long piece of needlework, of little use and no beauty'.

This fine hand screen, however, is both practical and beautiful. Hand fire screens were held by ladies to protect their delicate complexions from the heat of the fire. This example dates from the 1830s, and is worked on a fine and evenly woven linen canvas with very fine silk thread that has faded considerably on the front. The picture is of a wreath of flowers, including roses and auriculas, embroidered delicately in polychrome silk, the true colours of which can still be seen on the reverse.

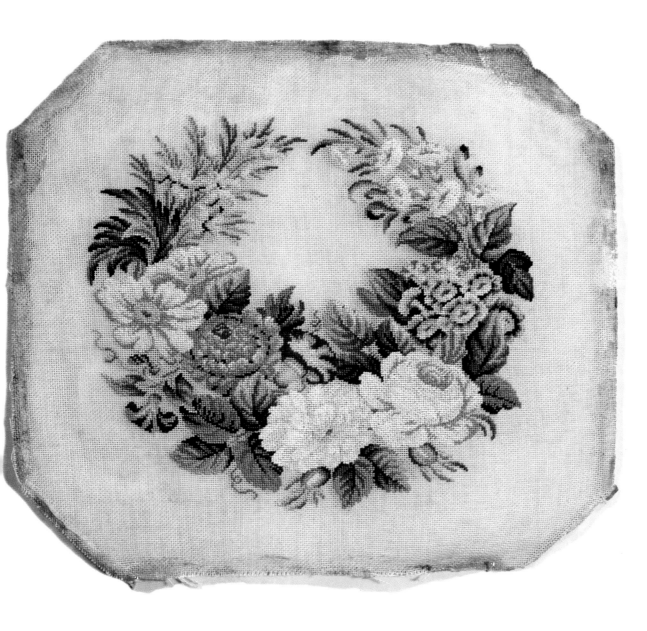

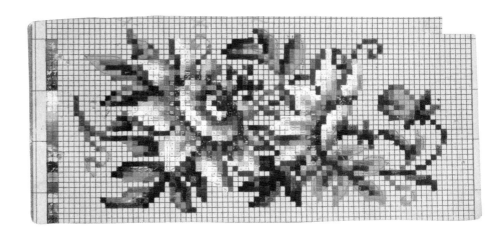

Berlin work is a form of canvas-work embroidery that became a craze during the 19th century. It originated at the beginning of the century, taking its name from Berlin where the first hand-coloured charts were produced by Philipson, a print seller. In 1810 the wife of another print seller, Wittich, persuaded her husband to print them in quantity and export them across Europe and North America.

In 1831 Mr Wilks opened a warehouse in London's Regent Street, importing all the material required. The charts were very expensive and could be returned and part exchanged for new ones. They were first printed in black and white and then delivered to outworkers who hand-coloured each chart. The wool was often merino wool which was high in bulk and with a little twist. The early wools were dyed with natural dyes until 1856 when William Perkins discovered mauve, the chemical aniline dye that produced brilliant colours in blue, magenta and pink. These were popularly known as 'gaslight colours' because they did not lose their colour under the glare of gas lighting, which tended to reduce all blues and purples to an unprepossessing grey.

These woolwork charts date from the mid-19th century.

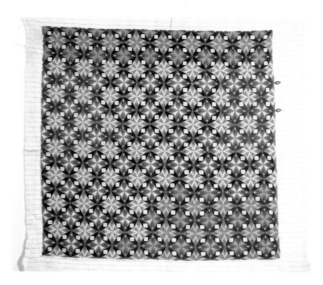

The Victorians used Berlin woolwork for a whole range of purposes from carpets, and cushions to bell pulls, waistcoats, slippers and braces. In *A History of Needlemaking* published in 1852, M.T. Morrall laments the passion amongst young women for such crafts:

'I hate the name of German wool, in all its colours bright;/Of chairs and stools and fancywork, I hate the very sight:/The shawls and slippers that I've seen, the ottomans and bags/Sooner than were a stitch on me, I'd walk the streets in rags.
 Ah! The misery of a working wife, with fancywork run wild,/ And hands that never aught else for husband or for child: /Our clothes are rent and minus strings, my house is in disorder,/And all because my lady wife has taken to embroidery.'

This square of canvas, dating from *c*. 1850, is embroidered with Berlin wool in Florentine stitch in a typically geometric pattern based on octagons and squares. A label attached to the object notes it 'belonged to Mrs Wade at Yoxford'. Yoxford was the Suffolk village where Charles Paget Wade was born, so presumably this cover was inherited from his grandmother.

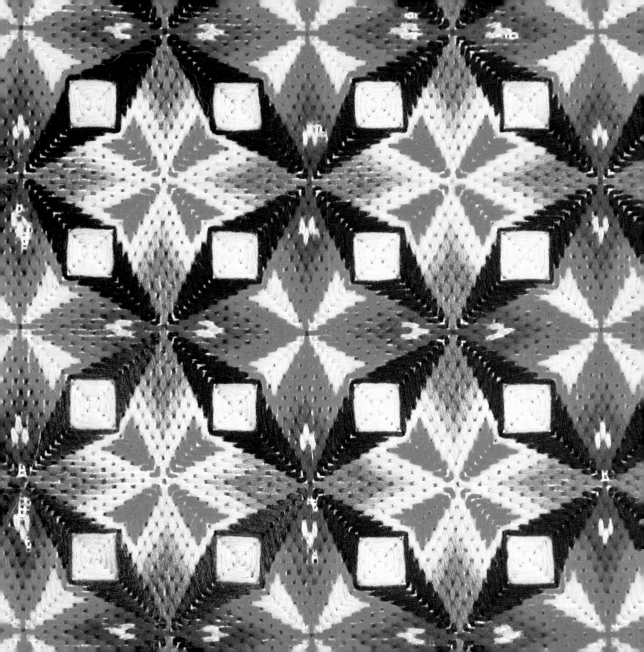

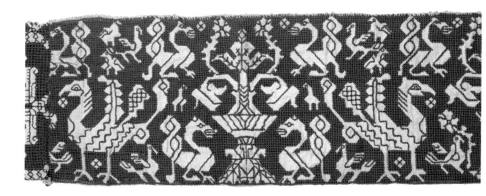

Assisi work is the term now usually applied to cross stitch where the design is treated in reserve on a ground of cross stitch. It is named after the Italian town where the style was revived in the 19th century. However, earlier versions of this work used outlines of back stitch, buttonholing or whipped running, and sometimes little decorations appear within the voided areas.

Wade had several examples of Assisi work in his collection. This one is on linen and embroidered in crimson linen thread. The voided design is of mythical animals, acorns and oak leaves very much in the Italian style. There are details in double running stitch and the background is in overcast stitch.

The date and purpose of the panel are not known, but it was probably originally applied to a garment or hanging.

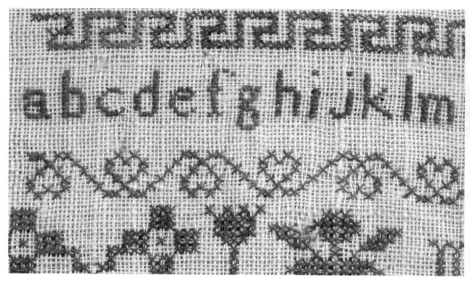

By the 19th century the sampler had become not so much an aide memoire (pp. 60-63) as an example of proficiency and a class of embroidery in its own right. Samplers tended not to explore the whole range of stitches but relied on cross stitch and petit-point combined with uplifting and moral verses.

This sampler is typical of the 19th-century composition that included motifs, alphabets and verses often concerned with morality and death. It is worked on an open linen canvas in red cotton thread, and consists of three alphabets, two sets of numerals in cross and eye stitches and the legend:

Jesus permit thy gracious name to stand,
As the first effort of an infant's hand;
And while her fingers on the canvas move,
Engage her tender thoughts to seek thy love.

Rebecca Ducker. Aged 8 years December 13th MDCCCXXXI'

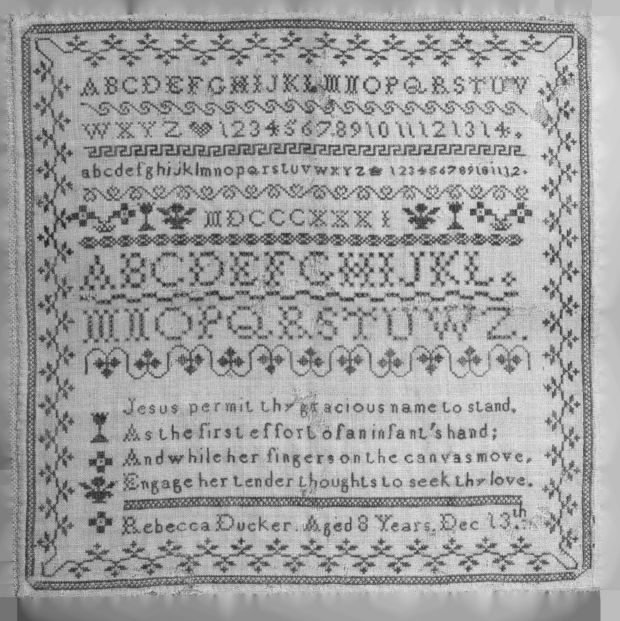

ABCDEFGHIJKLMNOPQRSTUV
WXYZ ♥ 1234567891011121314.
abcdefghijklmnopqrstuvwxyz & 1234567891011 12.
MDCCCXXXI
ABCDEFGHIJKL
MNOPQRSTUWZ.

Jesus permit thy gracious name to stand,
As the first effort of an infant's hand;
And while her fingers on the canvas move,
Engage her tender thoughts to seek thy love.

Rebecca Ducker. Aged 8 Years, Dec 13th

This pair of braces, dating from the 1830s, is made from cotton webbing with a decorative cover of silk which is edged with bunting-azure silk ribbon and lined with shell-pink silk satin. The braces are embroidered in tent stitch in polychrome silks in a chinoiserie design of human figures, flowers, and leaves with a stylised house in the centre. The initials 'B' and 'R' (or 'K') decorate one of the braces and 'C' and 'D' the other.

Coils of metal covered in silk form the attachments for buttoning – the buttonholes being reinforced with soft leather. It wasn't until 1869 that *The Tailor & Cutter* advocated the newly available elastic:

'none of the new-fangled notions of braces surpass or even equal the plain elastic web with the double sliding ends'.

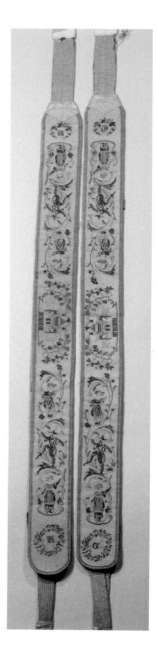

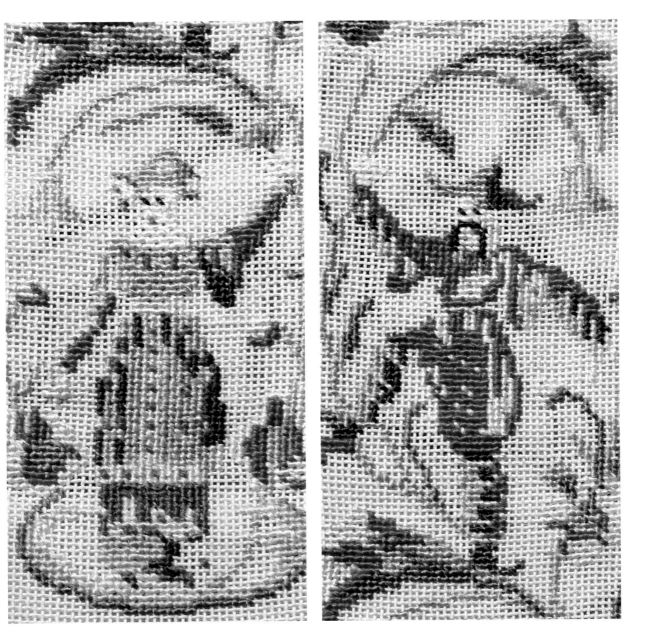

The reticule provided an ideal embroidery project for ladies of the house with increasing amounts of time on their hands. Many English women's magazines contained instructions for embroidery patterns for small accessories. Ready-made frames were available for purses and reticules, which were often made up to match or co-ordinate with an outfit.

This delicate cream silk reticule, from the 1840s, is made from canvas and is embroidered on both sides with wool and silk. On one side it is embroidered in shades of green with a pink rose, on the other, with green with a yellow rose and gilt beads.

The central flowers are worked in tent stitch with a heavier border of cross stitch. The edges are bound with cream silk cord and the top with cream silk satin. Cream chenille tassels decorate either side, and there are two long, silk cord handles.

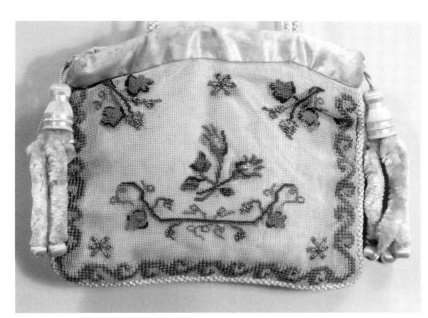

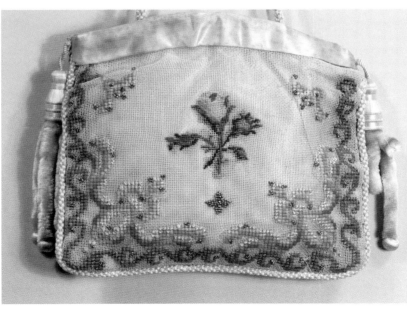

Waistcoat

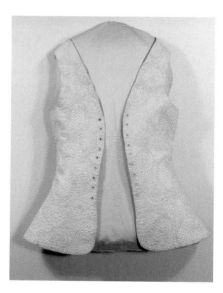

Quilting is a form of needlework in which either the outlines and some details of the pattern are padded with thin rolls of cotton wool pushed between the lining and the surface, or where the design is worked through two or more layers of padding and material.

This delightful early 18th-century quilted waistcoat is typical of the sort of garment, sometimes known as a jump, that would have been worn for informal occasions where greater ease of movement was required, such as riding or during pregnancy. This example is made from a fine linen top layer and a lower coarser linen. It is quilted all over with cream two-ply silk in backstitch in a design of small feathers and 'rose window' marguerites threaded with twisted sheep's wool. The ground is covered with an overall pattern of small lozenges. The cut suggests it was made from another piece, probably a coverlet.

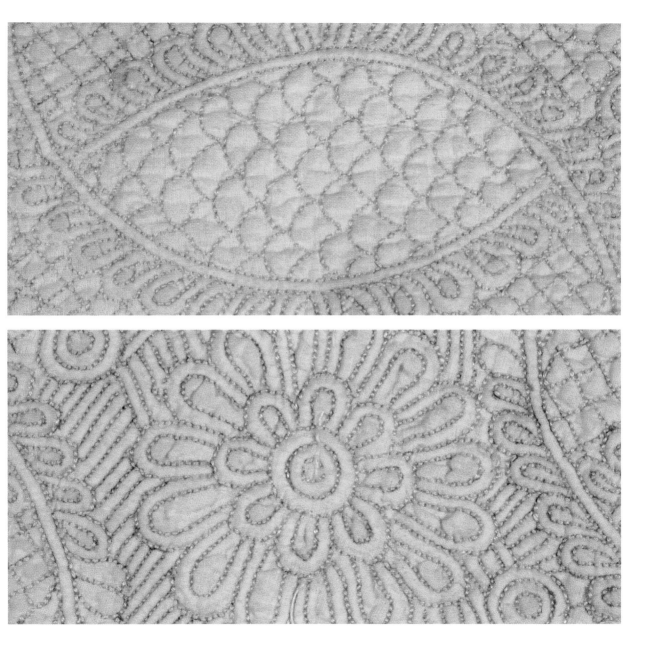

Child's Dress

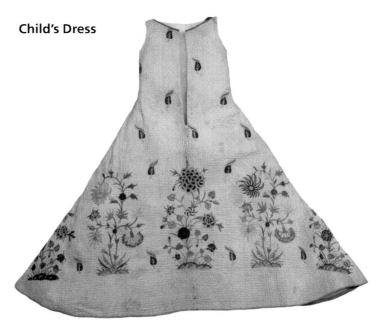

The primary function of quilting has always been to provide warmth through the layers and padding. But it has also provided enormous potential for the interplay of two- and three-dimensional design.

This charming example of early 18th-century quilting was probably formerly a bedspread. It is made from tightly woven unbleached linen with a backing of a looser weave linen. It has a close backstitched lozenge ground and a sequence of colourful bouquets on hillocks in chain stitch in polychrome coloured twist silks. The ground is all-over embroidered with scattered isolated leaves in maroon and gold. It has been cleverly transformed into a child's pinafore, pieced in such a way as to preserve the integrity of the quilting and the beauty of the design.

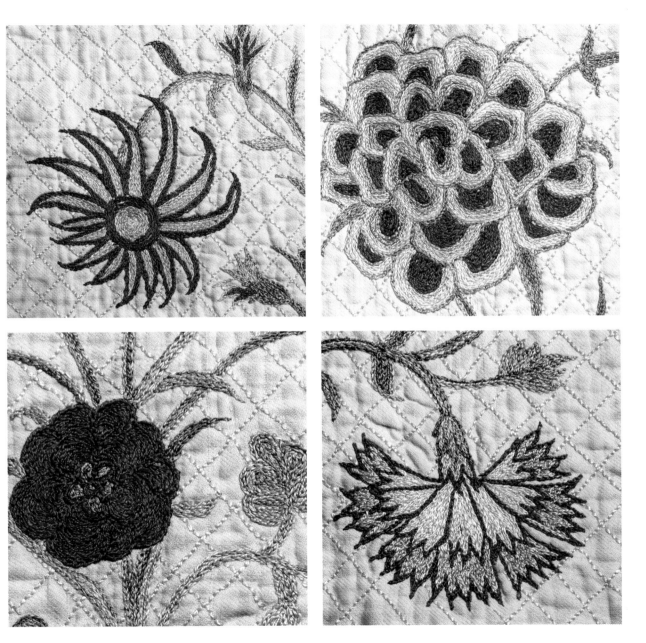

This example of early 18th-century quilting is technically 'fake' in that it consists of just one layer. The piece is likely to be of Indian origin, used for furnishing. It is made from a rectangular piece of twilled linen with rounded corners. The hemmed edge has a drawstring which pulls up in the centre of the two opposing sides. The design is executed in a fine chain stitch in yellow silk with additional decoration in stem, back and eyelet stitching. The chain stitch may have been worked with a tambour hook, extensively used in Indian embroideries (see pp. 34-5). The ground is covered with a vermicular pattern.

The design compares stylistically with the waistcoat on pp. 80-1, highlighting the extensive cross-fertilisation in design throughout this period.

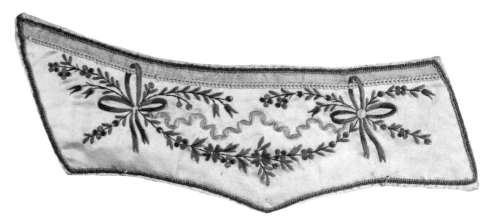

China ribbon embroidery was particularly popular from the late 18th century. The ribbons were soft enough to be used in a needle in the same way as thread. The technique was revived again in the 1880s in a slightly coarser form known as rococo work.

These pocket flaps and one edge are all that remain of a man's waistcoat from the late 18th century. The base material is a cream satin which has been worked with sprays and ribbon swags in fine satin stitch in crushed strawberry shades. What brings the fine shaded embroidery even more to life is the use of chartreuse-yellow China ribbon in the design.

Around the edges of the pocket flaps are tiny sequins made from stamped vellum edged with a chenille boundary.

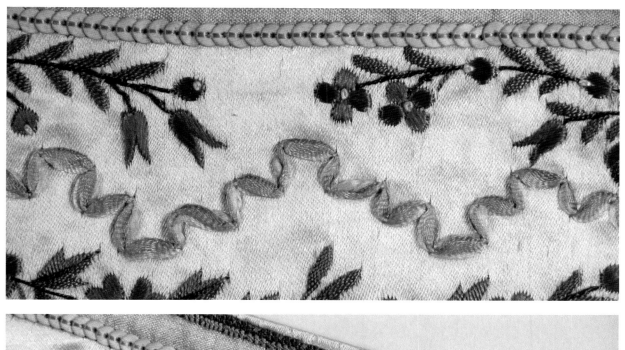

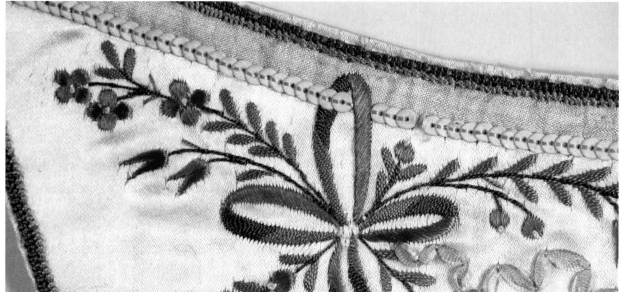

Pin Cushions & Needlebook

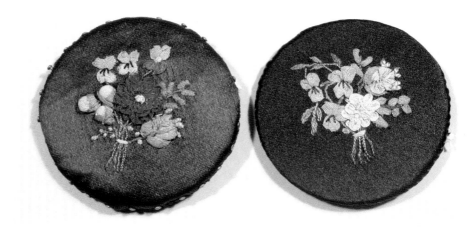

As with fashion accessories, sewing accessories such as pin cushions and needlebooks were a product of a genteel young girl's sewing activities. They were often given as gifts. Jane Austen made a case for her sister-in-law, and enclosed a paper with the verses:

This little bag, I hope will prove
To be not vainly made;
For should you thread and
 needles want,
It will afford your aid.

And as we are about to part
I will serve another end:
For when you look upon
 this bag,
You'll recollect your friend.

The pin cushions, above, are typical of the mid-19th century, made from two discs of card covered with silk, one in green, the other in black. Both sides are decorated with flowers in multicoloured fragments of ribbon and silk thread.

The needlebook, right, is also made from two circles of card covered with purple/navy silk and lined with green striped silk. The top piece has a design of a bunch of flowers in pink silk ribbon, yellow, pink, white and blue beads, and leaves in green wool thread.

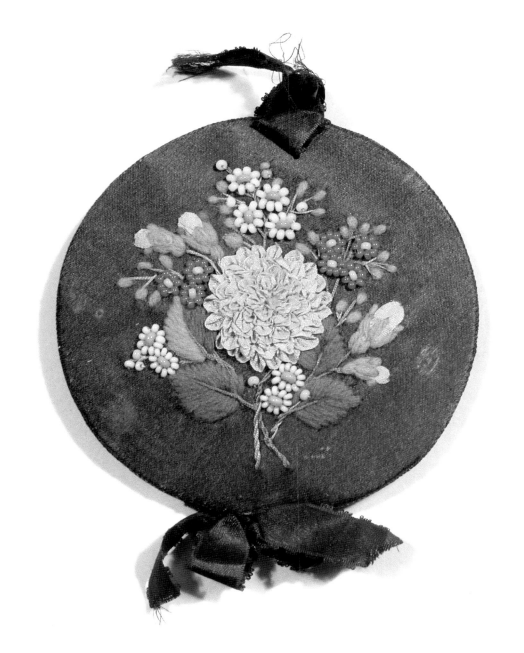

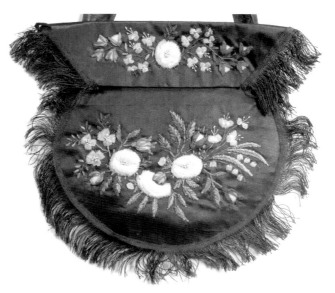

Some very extraordinary materials have been used in embroidery. For example, the scales of perch, carp and goldfish were often gathered, cleaned and sometimes tinted for use as decoration for accessories in the 19th century. Whilst damp a hole was made for them to be stitched into place and the edges often cut to decorative patterns. The scales were then used to form such details as petals in floral motifs in conjunction with embroidery in silk threads. Eventually this passion for novelty – which also included designs using feathers and insect wings – led to accusations of exploitation.

This black silk satin reticule dating from the 1830s is embroidered on one side with fish bones, and silk floss, chenille and ribbons in shades of green to add to the texture. The design is of roses, buds, flowers and leaves. The lining is of dawn-pink silk. It is edged with black silk fringe and there are black silk ribbon handles.

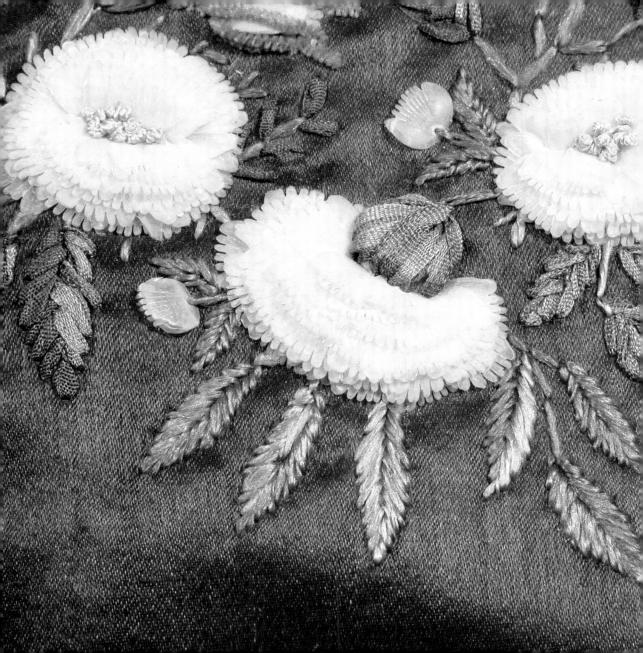

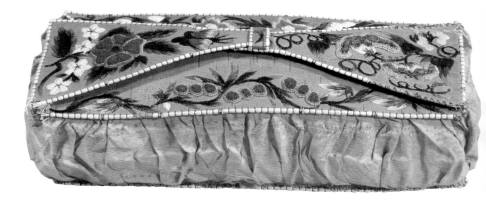

Wade collected several pieces that showed the skill and ingenuity of the North American Indians, who greatly influenced embroidery during the 19th century.

This little case dating from the late 18th or early 19th centuries is made from natural birch bark with sides of pink silk. The top piece is richly embroidered with moosehair – very much an indigenous craft of the North American Indians.

The actual designs, however, show the influence of the French Ursuline nuns who settled in Canada in the 17th century and taught European designs to the Indian girls in their convents. Long and short stitch, satin and french knots have all been used.

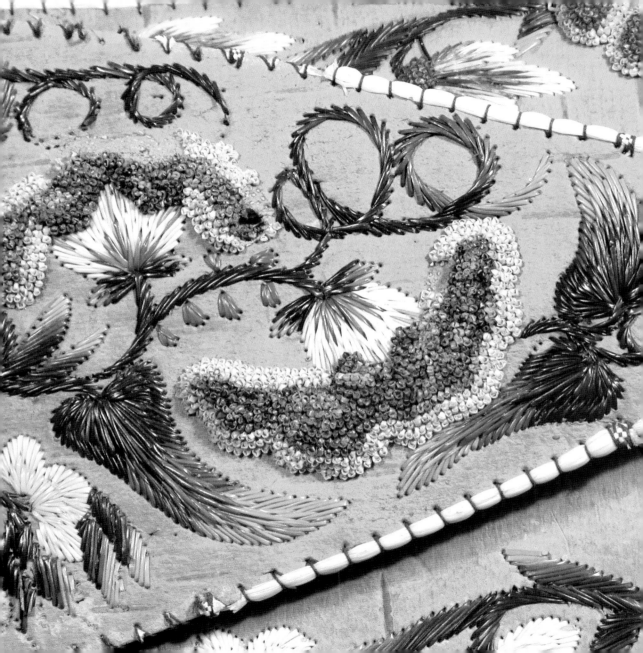

Glossary

ASSISI WORK named after the town in Italy where the technique was revived in the 19th century. The cross stitch designs were worked in reverse with the background being filled in and the designs appearing as 'voids' in the stitching. It was worked on cream linen ground fabric, usually with red thread.

BERLIN WOOL WORK the name comes from the hand-painted charts originally produced in Berlin in the early 19th century. The soft merino wool threads that were spun for this canvaswork embroidery were originally naturally dyed, but the craze for the charts coincided with the discovery of chemical dyes so that Berlin wool work is now synonymous with Victorian canvaswork in garish colours.

CHENILLE soft velvety thread that takes its name from the French word for caterpillar.

COGGESHALL LACE machine-made net bobbin net, originally manufactured in Coggeshall in Essex. The ground was embroidered with flowers and foliage in chain stitch, generally with a tambour hook. Also sometimes referred to as Limerick lace.

COUCHING thick threads that are too large to pass through fabric are held down on the surface of the fabric with finer thread stitched at right angles to the couched thread. Seen in metal threadwork and similar techniques.

DRAWN THREAD WORK a form of whitework where the weft threads are 'withdrawn' in an area of the cloth and a separate thread is worked in to form decorative patterns with the remaining warp threads. Needle lace is also used for the finer decorative details, the finest form of this is Reticella, Italian cut work, Greek lace or Gothic point.

DRESDEN WORK very fine whitework drawn embroidery. Often used as a substitute for lace, it consisted of intricate patterns stitched onto a very fine fabric ground. Also known as point de Dinante, point de Saxe or toile-de-mousseline.

FLOSS SILKS untwisted silk fibres reeled from the silk cocoon. They are very fluffy and soft which makes them difficult to embroider with, but produce lustrous results.

LAID WORK a method of covering the surface of a design with long stitches of silk thread, which are then held down with other couched or stitched techniques, often in a design. This is also a technique used in metal threadwork.

METAL THREADWORK a term to cover all types of embroidery using metal thread in its different forms, sometimes referred to as 'goldwork'.

NEEDLEPOINT also known as canvaswork but wrongly called 'tapestry' (which is woven and not stitched). Designs are worked onto a stiff, even-weave cloth using wool or silk threads.

NEEDLE LACE used within different techniques and in different forms all over the world. It is basically formed with buttonhole stitches. Although it looks in some cases like bobbin lace, it is formed with needle and thread. The finest form is seen in Reticella.

PASSING metal thread used in gold work, consisting of a fine metal strip wrapped tightly round a cotton core. It is couched down to the work, and being a firm thread it is particularly effective for crisp designs.

PLIÉ used in metal threadwork. As the name suggests, it consists of a number of lengths of fine passing thread twisted together to make a cord that is often used as an edging. Also known as twist thread.

PULLED THREADWORK a form of whitework embroidery where the ground fabric (usually an even weave cloth) is embroidered with a series of patterns counted on the weave of the cloth. The sewing thread is pulled tight with each stitch to produce a lacy background.

PURL a hollow metal thread formed by wrapping a very fine wire around a former (often a long needle). The finished thread is cut into lengths and sewn down using sewing cotton, and treated as if it was a bead. This versatile thread produces the textures within metal thread embroidery.

QUILTING the embroidery technique of running or backstitch worked in patterns through a cloth with a layer of padding underneath. Alternatively, cotton or wool padding can be pushed through channels stitched in a double layer of cloth to form patterns.

RETICELLA *see* Drawn Thread Work and Needle Lace

RIBBON WORK fine silk ribbons in varying widths stitched through a silk backing fabric as with an embroidery thread. The ribbons are manipulated to produce three-dimensional flowers and foliage.

SILK SHADING long and short stitches used to produce a smooth surface where subtle changes of colour give a highly realistic effect: the technique is also called needle painting. The 'silk' in silk shading refers to the thread used, which is predominately floss.

SLIPS a section of embroidery worked separately and then applied to the main piece of work, sometimes over a padded ground.

TAMBOUR WORK a method of producing continuous rows of chain stitching. The fabric is stretched taut in a tambour frame (circular wooden hoop), with the thread worked through the fabric using a fine hook.

WHITEWORK The many techniques of embroidery where white threads are used on a white ground fabric.

First published in Great Britain in 2004
by National Trust Enterprises Limited,
36 Queen Anne's Gate
London SW1H 9AS

www.nationaltrust.org.uk

ISBN 0 7078 0386 1

Designed by SMITH

Editorial and picture research by Margaret Willes
Colour origination by Digital Imaging Ltd. Glasgow
Printed in China by WKT Co.Ltd.

Cover: Early 19th-century nightcap (see pp.14-15)
Half-title: 16th-century drawstring purse (see pp.36-7)
Frontispiece: 19th-century sampler (see pp. 74-5)
Title: Part of a 16th-century bodice (see pp.10-11)